Gift of

The John W. Bowman Family

in memory of

TIMOTHY DILLON BOWMAN

contemporary
women Artists

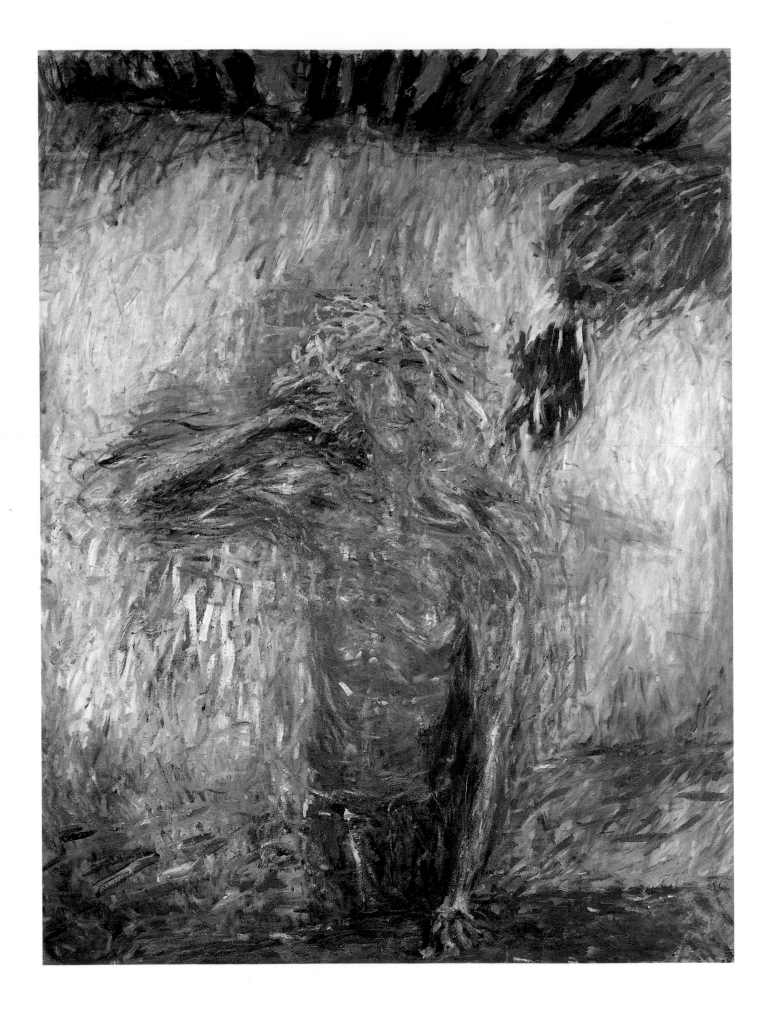

contemporary women Artists

wendy beckett

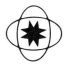

universe · new york

This book is dedicated to all those who have helped me with art books and
magazines, especially Joanna Battaglia, Hazel Hall, cousin Brendan, my Notre Dame
sisters, and above all, that supremely generous benefactor and loving friend, Delia Smith.

Photographic acknowledgements

*Elizabeth Butterworth, Prudence Cuming Associates Ltd.; Eileen Cooper, Photo: Blond Fine Art Ltd.; Elizabeth Murray, Photo: Geoffrey
Clements; Cindy Sherman, Photo: with kind permission of Schirmer/Mosel Verlag, Munich.
Plate 2 Zindman/Fremont, New York; Plate 5 Prudence Cuming Associates Ltd.;
Plate 6 Ivan Della Tana, New York; Plate 7 Lisa Kahane, New York*

Half-title: Bridget Riley, detail of *Ra* (see page 92)
Frontispiece: Susan Rothenberg, *Elizabeth*, 1984-5. Oil on canvas, 180.5 × 138.4 cm.
Collection Edward Reynolds Downe, Jr.

Published in the United States of America in 1988 by Universe Books

381 Park Avenue South, New York, N.Y. 10016
© Phaidon Press Limited, Oxford 1988

US Cataloging in Publication Data

Beckett, Wendy
Contemporary women artists/Wendy Beckett.
p. cm.
Bibliography: p.
ISBN 0-87663-691-1 : $24.95
1. Feminism and Art. 2. Women artists—Biography—History and criticism.
3. Art, Modern—20th century. 4. Women's studies.
I. Title
N72.F45B43 1988
704'.042'0904—dc19

88 89 90 91 92 / 10 9 8 7 6 5 4 3 2 1

Typeset in Perpetua by Tradespools Ltd., Frome, Somerset
Printed in Great Britain by The Eagle Press plc, Glasgow

contents

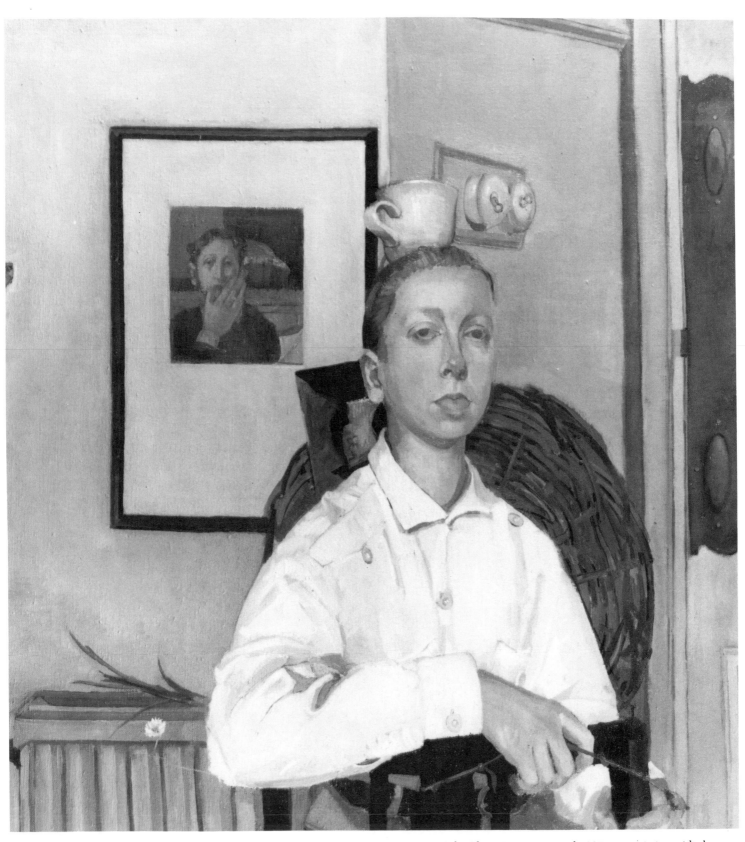

1. Alison Watt, *Self portrait with a tea cup*, 1987. Oil on canvas, 101.6 × 138.4 cm. 1st Prize John Player Portrait Award 1987 in association with the National Portrait Gallery

introduction

This book is not intended to be a survey of contemporary women artists; the field is too vast. There are literally hundreds of gifted and creative women in our contemporary world, and rather than merely list or name or even categorize them, I have made a personal choice, a partial selection. What I would have liked to call the book is 'Certain Contemporary Women Artists', to emphasize this selective personal element. 'Certain' also has another meaning, and it is this meaning that has fundamentally determined what the choice should be. In Norman Mailer's *Pieces and Pontifications*, there is a reference to science and art in which science is characterized as being 'articulately uncertain', while art is 'inarticulately certain'. That inner certainty, which is too deep to be articulated and too personal to the artist's sense of self to be captured in any concept – that certainty is what distinguishes all the artists in this book. At some mysterious level of truth, they 'know' what they are doing. Barnett Newman, struggling to find his spiritual feet after the horrors of the Second World War, spoke of art as serving 'man's natural desire . . . to express his relationship to the Absolute . . . [his] natural desire for the exulted, for a concern with our relationship with absolute emotions'. Many contemporaries would dismiss this as rhetoric, yet behind all the big words is a pure and strong belief in the value of art. However subconscious it may be, some such belief is implicit in the humble confidence, the 'certainty', which is evident in every artist whose work I have found it rewarding to contemplate. We are living at a time when the term 'Artistic Renaissance' is being bandied about. Only time will tell whether the quality of the work in any way deserves this honorific, but it is justified if our criterion is quantity. Yet, despite the quantity, and indeed, much of the quality, many people fight shy of contemporary art. They will confidently dismiss or accept the latest book or play, and feel competent to criticize contemporary ballet or music, but they seem unable to recognize and trust their reactions to the art of their own time. If questioned, they all too often confess to suspicion. If one feels that a certain piece of work is childish nonsense, yet the cognoscenti are in raptures, who is right? Are they having us on? Rather than lose one's dignity and make a fool of oneself, one may steer clear. But this is an enormous impoverishment. The best of contemporary art is so very good, so subtle and so beautiful, that we should not lightly turn aside from it.

However, nothing in life is free. If we want to appreciate art, the first sacrifice we must make is time. If, say, you want to read Murdoch's *The Good Apprentice* then you have to set aside several hours, and if you want to read Proust, you have to set aside many hours. However quick a reader you are, to assimilate a work of literature takes time. The same holds for music and drama, except that here it is others who regulate the time, and we conform to this. In other words, all art takes time, just as much as it takes place. Walking rapidly – or even slowly – through a gallery is equivalent to browsing through a bookshop and reading the blurbs. Before the Russian Revolution, a wealthy merchant named Shchukin bought one after another of Matisse's paintings, sometimes holding at bay his initial feeling of dislike. In a moving letter, Shchukin told Matisse how he spent the first hour of his day sitting in front of a single picture and

contemplating it. Eventually, it 'revealed itself' to him, and he began to love it. A picture or sculpture has to be 'learned', 'read', 'listened to', and that takes time.

Kenneth Clark, who was in a position to know, claimed that one could not look at art for more than a few minutes, then one needed to look away, say something, take an intellectual breather, as it were, before returning to the art with renewed resources. The commentaries I have provided are merely this: intellectual breathers, designed to hold a reader's eyes on to the page until the art begins to reveal its inner power. In themselves, the commentaries have little value, but they may be a means of detaining the reader within the forcefield of what really matters: visual equivalents of the 'glittering eye' and bony clutch of the Ancient Mariner. All serious art needs time to allow us to recognize it. Once we have made contact, the relationship has no need of another person's interpretations. What others think may be interesting and helpful, but it does not really matter very much. It is our own reaction that is all important.

This is true of all art, but particularly of the art of our own times, which poses such a challenge of faith. Although Shchukin had no guarantee that Matisse was the great artist he thought him, he took the plunge of trust, and was rewarded. This kind of daring is, in fact, far rarer than one would think. I. A. Richards, a don in the English school at Cambridge, wrote a book called *Practical Criticism* in which he demonstrated our unwitting dependence on labels. He presented the students with a set of poems each week, from which he had removed the poet's name, and asked them to discuss them. Deprived of the labels, the students floundered hopelessly. Before they could ask 'What effect is this poem actually having on me?', they felt obliged to work out its credentials, its right to have any effect at all. Once they had decided that, yes, this was by Shelley or someone in that bracket, they could produce very sensitive criticism. Richards asks the reader not to look up the authors' names until after each exercise, and it can be a humiliating experience. An initial misjudgement will colour everything. It is also clear that few of the students really trusted their own judgement; yet unless we have reacted from our own truth, what use is our opinion? To assess these poems aright, one needed to take time, to think, to read around them, and finally to examine and put into words one's own independent reaction. With contemporary art, we are in this situation always, though only the professional critic need struggle to put his judgement into words. We are given some slight validation in that the art we see will normally be in a gallery or in a magazine or book, so somebody of standing evidently values it, yet even the professionals may be at variance. An artist like Jennifer Bartlett is lauded by some, sneered at by others; an artist like Agnes Martin, who some would consider among the very greatest, may not even be included in major international surveys. There are those who would value Helen Frankenthaler primarily for the influence she has had on Morris Louis and Kenneth Noland in her use of staining (putting the paint not on but in the canvas), and there are those who would value her as a great artist in her own right. Obviously one does not want to dull one's intellectual edge by admiring some artistic fake, but that is the risk one has to take. If one gazes long enough, any work that is spiritually hollow will eventually unmask itself. The risk is more apparent than real.

There is another risk, though, with contemporary art, and one that is far more alarming. David Smith, the American sculptor, once said that he believed that 'my time is the most important in the world – that the art of my time is the most important art – that all the art before my time ... is history, explaining past behaviour, but not necessarily offering solutions to my problems. Art is not divorced from life. It is dialectic.' David Smith did not mean that he in any way thought little of the art of the past; he felt that it is enshrined in history. Time has adjudicated its merits, and the people for whom it was contemporary, from whose real lives and times it sprang, are all dead. We can admire this art from a safe distance. We unconsciously categorize it. It is all too easy to look at a Raphael Madonna, acknowledge its subject, and pass on untouched. Indeed, it is difficult, it takes real effort, if we are to let the art near enough to touch us, since it is almost inextricably entangled in assumptions that we may have to labour to recognize, let alone

2. Barbara Kruger, *Untitled (We have received orders not to move)*, 1982. Photograph, 182.8 × 122 cm. Dealer: Mary Boone Gallery, New York

discard. But contemporary art comes to us naked, free of all except the immediate. In that sense, Smith feels it is the most important. You will notice that he gives as his reason a moral judgement: it offers 'solutions to my problems'. He is, of course, speaking as a working artist, yet this existential challenge is precisely what can frighten us in the art of our contemporaries. Peter Hall, in his diaries, says: 'Great art changes one.' That is, in fact, a working definition of great art. If one has truly 'seen' it, one has become more completely human. Nietzsche saw 'mythless man' as 'eternally hungry', digging and grubbing 'for roots', and finding them in art. The American critic Harold Rosenberg called works of art 'the formal sign language of the inner kingdom – equivalents in paint of a flash, no matter how transitory, of what has been known throughout the centuries as spiritual enlightenment.' We are shy, today, of this kind of language, yet this spiritual dimension is the reason for art's importance, and for our need for it, whether acknowledged or ignored. Stanley Kunitz wrote that, in the best painting 'as in authentic poetry, one is aware of moral pressures

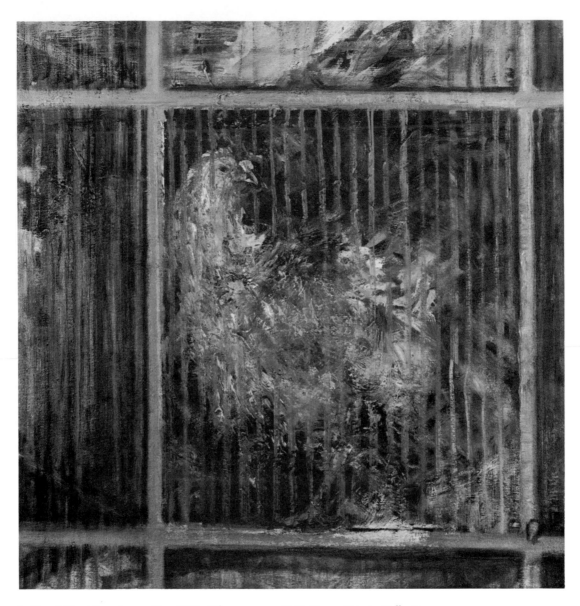

3. Maggi Hambling, *Battery Hen*, 1986. Oil on canvas, 61 × 61 cm. Private Collection

exerted: an effort to seek unity in the variety of experience. . . . The world is defended by art . . . it constitutes a moral universe.' Moral pressure is not something we gladly welcome. Exposure to the best in contemporary art exposes us to insights into ourselves that may not please, and may ultimately demand commitments from which, at present, we shrink. No wonder we are slow to embrace it, and rationalize our fear to ourselves and others. All the same, we are changed, by art or by anything else, only to the degree that we choose to be changed. This fear, like most other fears, is illusory.

It is, however, difficult to make a wise generalization about contemporary art because of its immense diversity. It ranges from delicate humour (Paula Rego) to the sardonic and cool (Jenny Holzer), from the geometries of passionate abstraction (Dorothea Rockburne) to portraits (Maggie Hambling), landscapes (Sylvia Plimack Mangold) and still lifes (Lisa Milroy), and is powerful in every kind of contemporary medium, from the fairly familiar, such as photography

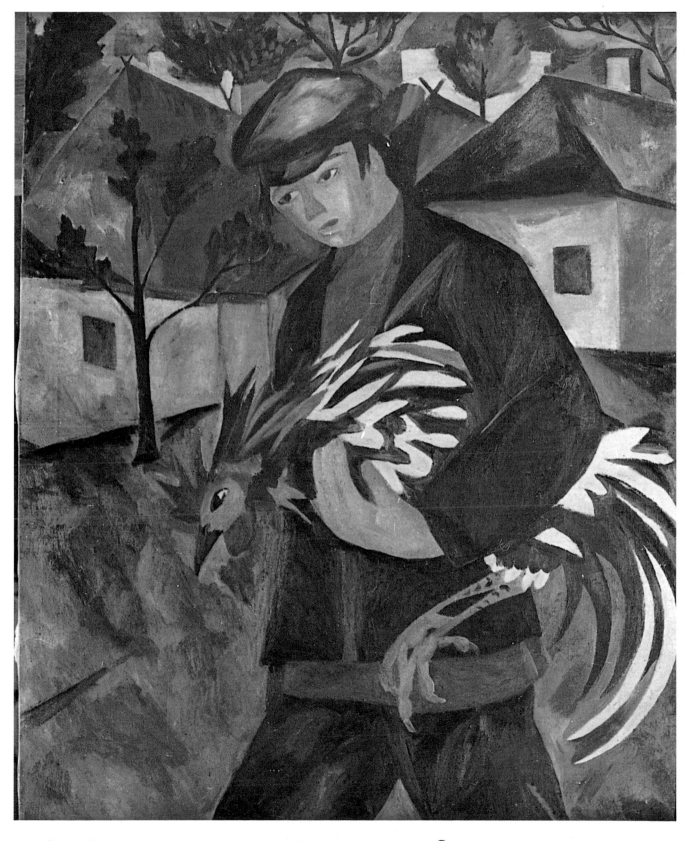

4. Natalia Goncharova, *Boy with a Cockerel*. State Picture Gallery of Armenia in Erevan © ADAGP, Paris and DACS, London 1988

(Cindy Sherman) to the weirdly unfamiliar, such as knitting (Rosemarie Trockel) or tapestry (Marta Rogoyska) or draped cloth (Lili Dujourie). The suggestion has been made that contemporary art can be defined as having no definition. It also struck me, thinking of how many of my favourite artists are women, that another loose 'definition' could be that it is the first art in which both human sexes are important. There have always, of course, been women artists. Most people interested in art can immediately name two or three – Rosa Bonheur, for example, and Angelica Kauffmann and Elizabeth Vigée-Lebrun. There are significant women among the Russian avant-garde – Exter, Popova (who died young), Rozanova, Goncharova, to name a few – but their significance is as rank and file, not as leaders. A better candidate for leadership, though these things are almost impossible to prove, would be Georgia O'Keeffe, who was born, like the Russians, in the eighties of the last century, but demonstrated her capitalist stamina by living well into the eighties of this. She could recall how a male fellow student told her that he would be a great artist, but for her, as a woman, there was nothing ahead but a career as a teacher. The power of her work, in its superbly confident simplifications and bright, clear colour, is surely a factor in making such a statement for ever more untrue. O'Keeffe's paintings can have a sort of magnificent vulgarity, but at their spirited best may well have influenced the development of American Abstraction. The first woman whom we can without hesitation acclaim as a major artist is surely Barbara Hepworth. Although she was to some extent overshadowed by Henry Moore (how extraordinary that Yorkshire should produce, within five years, two such sculptors!), her supreme quality has been increasingly recognized over the years. She and Moore are both unusual in creating work that gathers strength from being sited in the open air, and there have been some unconvincing claims that, true though this is, her work is physically feminine, in comparison with Moore's masculine power. It would be as true to see Moore's re-iterated figurations of reclining women as feminine, and Hepworth's re-iterated phallic shapes as male. Except for art that specifically takes as its theme the artist's sexuality (such as Mary Kelly's), works of art come from a level of inner truth that transcends sexual difference. If, as we are told, the full human being has both male and female elements, then art, emerging only from such a fullness, cannot be more narrowly categorized. I have confined myself to certain contemporary women artists primarily as a means of making a choice possible, amidst so wide a range of potential.

There are some serious omissions in the list of artists I have chosen. The most obvious is that I have not included public or poster artists (neither term is exact) such as Jenny Holzer and Barbara Kruger. Both are major artists. Holzer was one of the four women in the 1985 Carnegie International (the others being Dorothea Rothenberg, Cindy Sherman and Dara Birnbaum, a video artist). But their work, so uniquely focussing the mind, is not intended for contemplation as such. Their art is a 'message', and once seen, the message is to be carried away and pondered. The work itself, visually striking, is valuable for what it does, rather than for what it is. An example of each should make this clear.

The sign on a spectacolour board that Holzer installed in Times Square, New York, read:

<div align="center">

EXPIRING FOR

LOVE

IS BEAUTIFUL

BUT STUPID

</div>

Once seen, her 'Truisms', as she entitles them, stay in the mind and illuminate dusty corridors. But one does not need to go on looking. Likewise with Kruger, whose work includes highly effective collage works in black and white, such as *We Have Received Orders not to Move*. Kruger says of this and other works: 'I replicate certain words and pictures and

5. Paula Rego, *The Policeman's Daughter*, 1987. Acrylic on paper mounted on canvas, 213.4 × 152.4 cm. Marlborough Fine Art

watch them stray from or coincide with your notions of fact and fiction. I see my work as a series of attempts to ruin certain representations and to welcome a female spectator into the audience of men.' Any attempt to comment on the immediate impact both women make, ruining and welcoming, would be otiose.

I have only included work that I think can not only bear the weight of contemplation but actively requires it. This has also ruled out works that are so essentially ironic or Borges/Barthes-inspired that their primary appeal – and it may be a very considerable appeal – is to the conceptualizing intellect. The 'beauty' of these works is often not physical but mental, whereas I have only included works which use the physical, as Plato desired, to draw us into something deeper. What this is is much more than mental, and is essentially too deep to be fished to the surface and held there by the net of concepts. Not all the works here included are equally 'beautiful'. Joan Brown or Sandra Mendelsohn Rubin, for

6. Sylvia Plimack Mangold, *July 1986*, 1986. Oil on linen, 101.6 × 61 cm.
Dealer: Brooke Alexander, New York

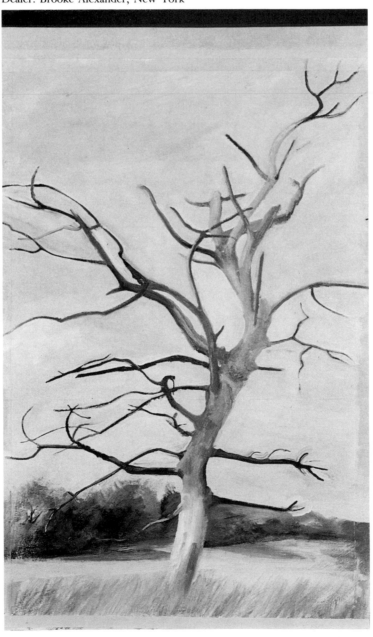

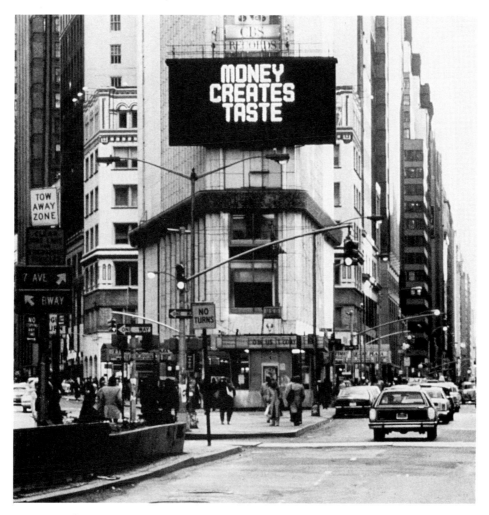

7. Jenny Holzer, *Spectacolor Board, Times Square, New York*, 1982. Dealer: Barbara Gladstone Gallery, New York

instance, create works more of power than of beauty, although it is power seen as truth, which Keats assures us 'is Beauty'. However, since there is an occasional moan from concerned art-lovers that contemporary art is no longer beautiful, an unbiased and prolonged look at the work of these artists may be a consolation. There can certainly be great art that is so passionately ugly that deformation becomes grandly beautiful, and perhaps Louise Bourgeois, the greatest living sculptor, is in this tradition (though I have not illustrated her by a major work where this particular power is manifest). All the same, though, and without wishing to be prejudiced, anyone who saw the Royal Academy Exhibition of Twentieth Century British Art will remember the large room in which the sheer beauty of the works of Ayres and, for those who could see them truly, Riley, provided an oasis.

I very much regret that many artists, both men and women, have had to be passed over. They are here, though, even if subliminally, since our response to the work of one artist deepens our capacity to respond to all art. I can never thank sufficiently our contemporary artists for the spiritual riches they have shared with me in their work.

Quidenham, 1987 Wendy Beckett

**magdalena
abakanowicz**

backs

1976–82

burlap and glue

80 pieces, 3 sizes:
61 × 50 × 55 cm,
69 × 56 × 66 cm,
72 × 59 × 69 cm

When the Nazis invaded Poland, Magdalena Abakanowicz saw drunken troopers fire at her mother, leaving her mutilated. It was then that the realization came to her that 'the body was like a piece of fabric – that it could be torn apart with ease'. Years later, as an adult artist, it has been her deliberate choice to work in fibre, the humblest of materials, fragile and yielding. The very softness was a challenge to her. She felt a terrible need to protest against the comfortable, the useful, the compliant, the 'soft', and what stronger protest than to show that 'this material could be a liberated carrier of its own organic nature'? The *Backs* come from a series of body works called *Alterations*. They are eighty in number, all different, though alike; eighty human backs without heads, without legs to their thighs, without hands to their arms. Most poignantly, the backs have no centres or fronts: they are hollow, each man hiding his own emptiness by crouching submissively. Although they have no sexual distinguishing marks, Abakanowicz formed them from burlap and glue on the plaster cast of a muscular male, and their potential for life, so sadly negated by their condition, comes through with a massive pathos. Yet we do not feel, and neither does Abakanowicz, that 'we' are these hollow crouching ones. No, it is more that we are the hollowers, the cause that others have no power. Human cruelty and indifference, human fear of being victimized ourselves: all the evil each knows within his or her own heart, this is what strikes us with fear and compassion as we meet this density of *Backs*. In its helpless misery, the sight may fill us with despair, yet a closer look reveals a strange, silent dignity. Whatever the unintelligible onslaughts of life may do to man, the human spirit can survive intact. Abakanowicz believes that 'Everything that surrounds us makes us and in making us, makes the work. So I believe that, if we are terribly honest with ourselves, what we say or write or do will touch everyone. It will touch others if it comes from deep inside, because there begins the contact between all people.' Paradoxically, the hollowness of the *Backs* speaks only of our need to be centred and to love.

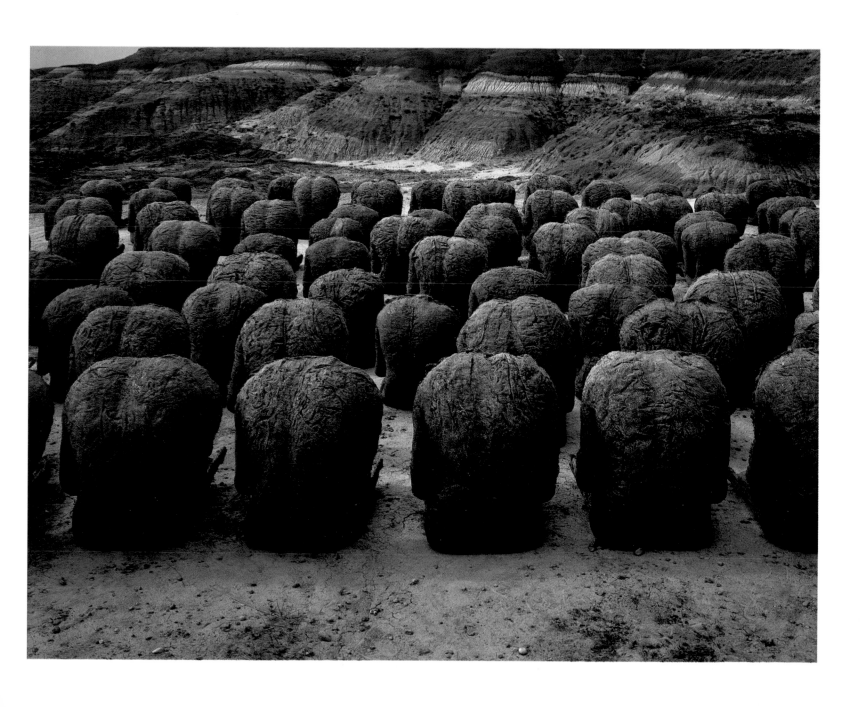

martha alf
four pears
1986
coloured pencil on paper
35.6 × 43.2 cm

To draw, making an artwork with pencil on paper, is to embrace impermanence; and to take as theme fruit and vegetable underlines that choice. We recall, however, that it is 'the least things', the 'little ones' that 'confound the strong', and Martha Alf has a profound purpose in her humble approach. She uses both her theme and the way she handles it for a mystical end. She has stated that she creates 'contemplative formal equivalents to mystical experiences'. That is, in fact, the only way in which a mystical experience can be 'communicated'. Words are too limiting, but a visual image, softly and tentatively called into being, can indicate what cannot be spoken. *Four Pears*, like the other pear forms Alf has been drawing for over ten years, glows with an unearthly luminescence that still allows the fruit its material reality. She uses a Derwent pencil, which subtly catches the tender nuances of a lowly life-form and renders it lovely. When she speaks about 'timelessness and a desire for endless time, but also about time's passage and time's end' these fundamental human longings somehow become visible in the very frailty of the pear bodies. They are so short lived, so ripe for our consuming, so sweetly unaware of anything but the light and their own closeness. This last element, the way the pears relate to one another, brings us to Alf's other purpose. She is revealing, mutely, simply, the human psyche. Two of the pears incline towards each other, and it is impossible not to see their relationship as anything but one of dependent love. 'One who loves and one who is loved': the larger pear allows the smaller to recline against it, accepting it but without a total reciprocity. And the upright pear that stands behind their embracing forms? An apparently bruised pear, its rounded surface marked, its stance proclaiming the dignity of one excluded. The most moving figure is the fourth pear, leaning forward with desire and hope. This is the most highly coloured of the four, its centre a rich purple, its outer skin a glimmering gold. But it is alone and unwanted. Small, humble, frail, beautiful, pregnant with meaning: the pears speak to us of the human heart and its hunger for spiritual wisdom.

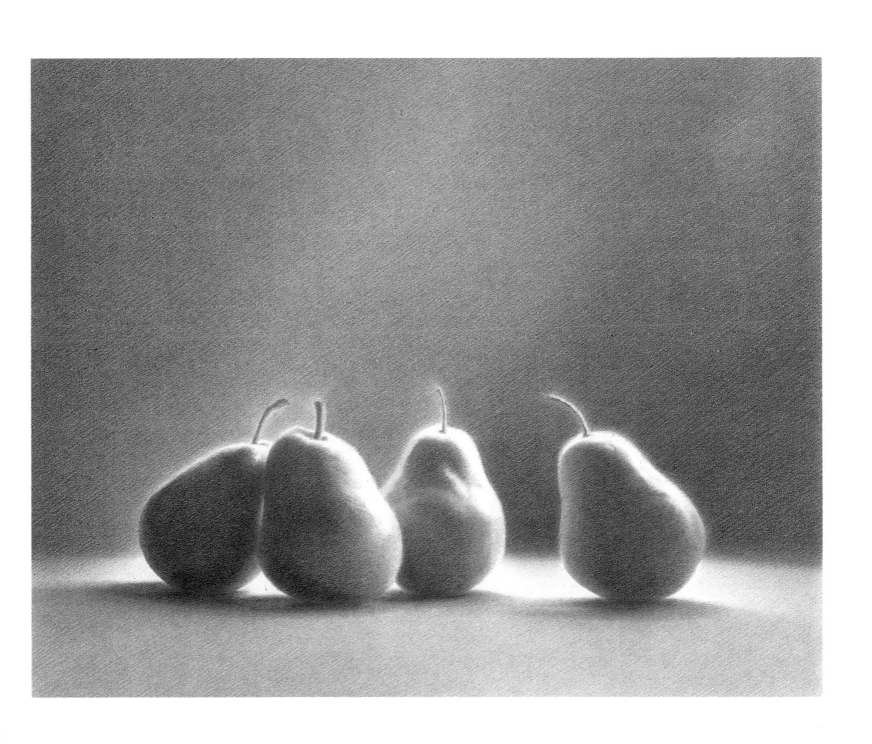

gillian ayres

a belt of straw and ivy buds
1983
oil on canvas
310 × 167.6 cm

Gillian Ayres has always been an abstract painter and she has always chosen poetic titles. This very large painting, over three metres high, is no exception. The title comes from Christopher Marlowe's *Passionate Shepherd*, a lyrical outpouring of inducements to 'come live with me and be my love'. A literal-minded critic, picking over the durability and tensile strength of straw and ivy buds would miss the point. The Shepherd's song is Passionate, not logical; he is creating an atmosphere, weaving a spell of freedom and joy. The golden straw they will lie on, the cool, dark buds they will strew around them – all these are romantic images. So in this lyrical painting, the arches of colour that plait their way throughout are not imitating the belt, or the darker arrowheads the buds. Ayres is creating, like Marlowe, an enchantment, a rich, vibrant world of colour, in which the warmth of love is spiritually present. She does not, in fact, entitle her works until they are finished and then does so in company with her friends. In the Tate Gallery *Catalogue of Acquisitions, 1982–84* she is quoted as comparing this naming to 'a christening'. She says that she likes and cares about her titles but 'they do not describe the painting'. They do, however, give us a pointer to the painting's 'feel', which is almost consistently, in Ayres, one of delighted response to the world's beauty. The free, joyous weavings back and forth that make her work such a visual delight, colour and form dancing a stately sarabande together with absolute control and strength, have only become characteristic since she has been able to give up her teaching job and move into a large and remote studio in the Welsh mountains. The space and solitude have evidently liberated some deep spring within her. Jubilant in the vision she shares with us in her canvas, she offers us, too, the potential of some deep, inner freedom. The bright markings are not ends in themselves; if we entrust ourselves to them they will lead us somewhere.

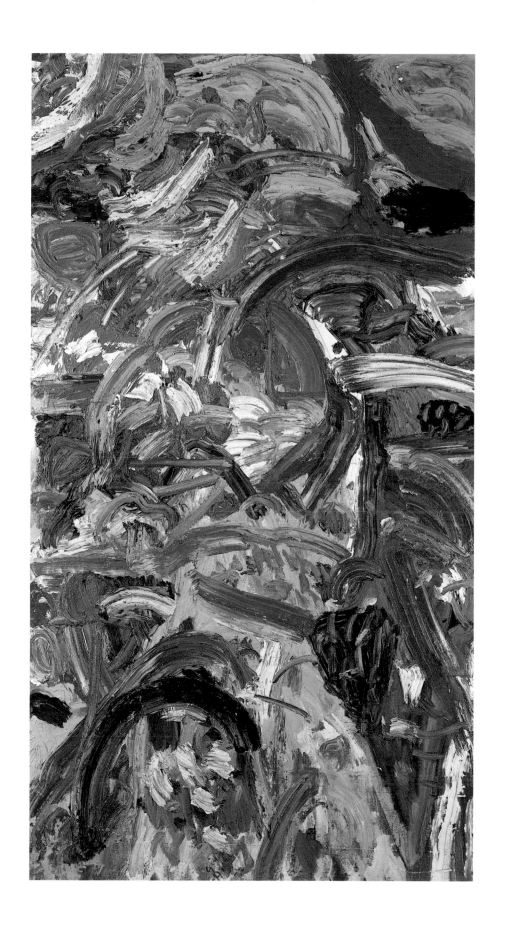

jennifer bartlett

the garden (detail)

1981

(from left to right)
baked enamel and
silkscreen grid, enamel
on steel plates
225 × 256.5 cm

Oil on canvas
228 × 198 cm

enamel on glass
236 × 122 cm

glass
25.5 × 205 cm

mirror
79 × 205 cm

oil on mirror
236 × 124.5 cm

In 1981 the Saatchis, the world's greatest patrons of contemporary art, invited Jennifer Bartlett (who had told them how overwhelmed she had been by the Matisse Chapel at Vence) to choose a room in their London house for an 'environment'. It was an inspired commission, because Bartlett is at her best when she is tied down and circumscribed, and thus enabled to look at her subject again and again, realizing a creative network of solutions and expressing them in a multitude of styles and materials. She semi-deliberately, one would think, made her task as difficult as possible – and correspondingly rich in potential – by choosing a small ground-floor dining-room with a low ceiling and walls so broken up by doors, fireplace, windows, etc., that there are nine discrete surfaces. Through a row of leaded windows one can see a courtyard garden with a pool, and Bartlett took this watered garden as her central theme. *The Garden* surrounds those who enter the room; it can never be wholly viewed as a single image and so 'conquered' or 'possessed'. Rather, anyone who enters must let *The Garden* conquer and display its mystery in slow unfoldings. Bartlett has used nine different techniques, and the detail shown here represents a baked enamel and silkscreen grid to the left, next oil on canvas, then enamel on glass beside the window, with mirror beneath the window and oil on mirror on the other side.

The grid of enamel plates, a favourite Bartlett medium, shows the gables of the Saatchi house glimmering in their reflection in the pool, and the powerful winter fresco which frames the coloured tiles around the fireplace. We see the garden in all seasons (autumnal, as here, with scattered leaves and the bare tree), in daylight and under the stars, in aerial view or in close-up, so that we can actually move down the steps in our imagination and enter the water. Near, far, hot, cold, mournful, exuberant: all aspects of the garden have equal validity. The soft impasto of one wall draws us. In another part of the room the glittering lacquer of the free-standing screen – not shown here – keeps us at a distance. Yet on this screen is the only animate element, the Saatchis' cat, amidst a stylized representation of all the garden's leaves. Typically, though, the cat appears twice: on all sides, nature confounds us, setting us free from our limitations and preconceptions.

louise bourgeois

stake woman

*c.*1970

pink marble

height 11.43 cm

If we define Surrealism as the art of the subconscious, then, apart from the young Giacometti, Louise Bourgeois is perhaps the only true Surrealist we have. Dali, Ernst, Magritte – in all their work there is a sort of playful intellectuality that intrigues but does not overwhelm. The images that Bourgeois fashions, though, well up from deep and terrifying places within her – and our own – psyche. It is impossible to be in their presence and not be touched; touched from many directions. She too can be playful, but it is a ferocious play with a massive sense of direction. *Stake Woman*, like the contemporary *Knife Woman*, is one in a series of sculptures, large and small, that recall prehistoric Venus figures; their breasts swell, their wombs rounden, they appear to be solely genital. Woman is seen as both Earth and Mother, a Power to be propitiated and yet only there for man's use. *Stake Woman* does not merely repeat the prehistoric insight, however. There is a profound duality, one that is crucial to Bourgeois' understanding of herself. If the woman is vulnerable, tied to the stake, then she is also terrifying, in herself a stake. A stake can be both a safely passive object and a dangerously active weapon. That blindly threatening head rises above the woman's helpless armlessness. 'She tries to be frightening, but she is frightened,' Bourgeois has said; 'she's frightened for the child she carries. And she's afraid somebody is going to invade her privacy or bother her in some way, and she won't be able to defend what she's responsible for.' She has also expressed this as a 'polarity', seeing within herself 'a drive towards extreme violence and revolt and . . . a need for peace, a complete peace with the self, with others, and with the environment.' All these profoundly human longings and drivings make themselves sternly visible in a work like *Stake Woman*.

Another very revealing comment was made recently to Robert Storr concerning the 'great luck' she has had in not being picked up by the art market. Her inexplicable neglect for many years (she was born in 1911) has been taken by Bourgeois as a pure 'blessing', enabling her to be totally true to her deepest consciousness.

joan brown

out on a limb

1986

acrylic on canvas

182.9 × 304.8 cm

At first sight, Joan Brown's work may seem unappealing, with its bright colour shouting at us and its obvious figuration. But once seen, it is remembered. It stays with us, as oblivious of rejection as its junkshop monkeys, and the longer we look at it, the more its subtleties speak. Brown has set a theatrical scene. On one side sit the traditional Three Wise Monkeys, obese and eunuchoid figurines, deliberately crude and without pretensions to real-life existence. Each perches on a decorated stand of the type we associate with the circus, and indeed their cowed obedience to proverbial function has the apathy of the caged animal, overtrained and bored. Even their sickly yellow colouring suggests death-in-life. 'Hear no evil, see no evil, speak no evil': is this truly wisdom? The query is put for us by the living monkey, the small wild creature on the other side of the picture. He is as vibrant as the circus animals are dead. To their smooth, hairless yellow he offers a richly modulated crimson, with all his senses quiveringly active and his long monkey-tail almost a fifth limb. He needs every limb he can have, because, Brown points out, he is actually 'out on a limb': no tree appears, only a slim branch jutting out from nowhere into space, and how safe he will be and where he will go next is a matter dependent only on the creature's wit and determination. Perhaps the absence of a visible sex-organ suggests that the monkey is female, a surrogate for Brown herself, who often uses an animal or mythological persona in her art. A live and vulnerable woman, then, questions those tamed and cowed by fear or prudence. Central to her theme is the majestic humming-bird which dominates the centre, much in the position that renaissance artists claimed for the Holy Spirit in religious art. But the bird is not the symbolic dove. Scarlet and ebony, silhouetted against the blazing azure, the humming-bird literally hovers, one of its rare characteristics, leaving the Brown-animal, perplexed and alert, time to make her vital decisions. Her work has known many forms over the years, but she has claimed always to have done 'what I thought was the right thing, and I ended up being accepted for it.' She leaves us no option but to accept.

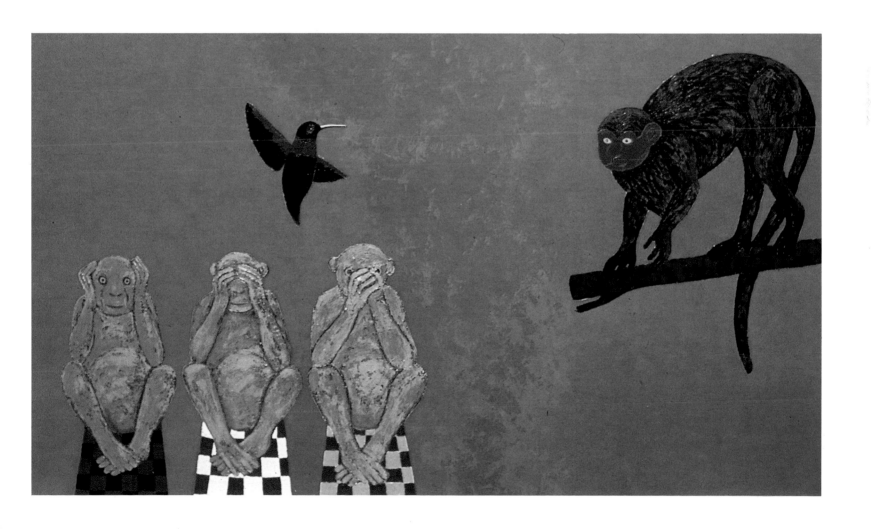

elizabeth butterworth

yellow-billed amazon parrot

1980

gouache on canvas

29 × 24 cm

Several contemporary artists express their vision through animal or bird imagery; one thinks at once of Nicola Hicks, or of the spectral presences of Deborah Butterfield's horses. But Hicks, Butterfield, Melissa Miller and others are making use of this imagery as a means to a personal end; it is their own visions they seek to express, and it often has undertones of the prevailing contemporary irony. What distinguishes the work of Elizabeth Butterworth is its innocent unconcern with any subjectivity. Her aim is to set before us, with the most passionate clarity, every nuance of shape and colour in the individual parrot or macaw with which she is confronted. It is a personal confrontation in the sense that only reverence and love, combined with superb and sensitive technique, could so truly see each bird in its own truth. *Yellow-billed Amazon Parrot* is one of a series Butterworth painted for a monograph on Amazon parrots by Rosemary Low, a leading British authority. These birds are under threat, as man greedily destroys more and more of their natural habitat, and though *Yellow-billed Amazon* displays the self-contained insouciance characteristic of the parrot, our knowledge of its vulnerability gives added force to Butterworth's objective delight in its beauty. She has illustrated the infinite subtlety of the bird's colour range, but she has given it no setting. It perches on nothingness, on a branch that falters and disappears. We may perhaps see this separation as a subconscious gesture of mourning: as things are at present, only death and disintegration lie ahead for this unique marvel of creation.

Butterworth keeps macaws and parrots in her home, studying them with an unsentimental affection. (Her first macaw she simply named 'Hen', a pleasing indication of her attitude: the bird is not a pet or plaything or surrogate human, but has its own and different dignity.) Butterworth can see the exquisite feathering, the most delicate gradation of greens and blues, because she is not concerned with her own importance. Her desire is to make wholly visible the absoluteness of the Amazon, to experience, in ego-less fidelity, its birdness, its validity as a wild and marvelous creature with specific gestures and beauty.

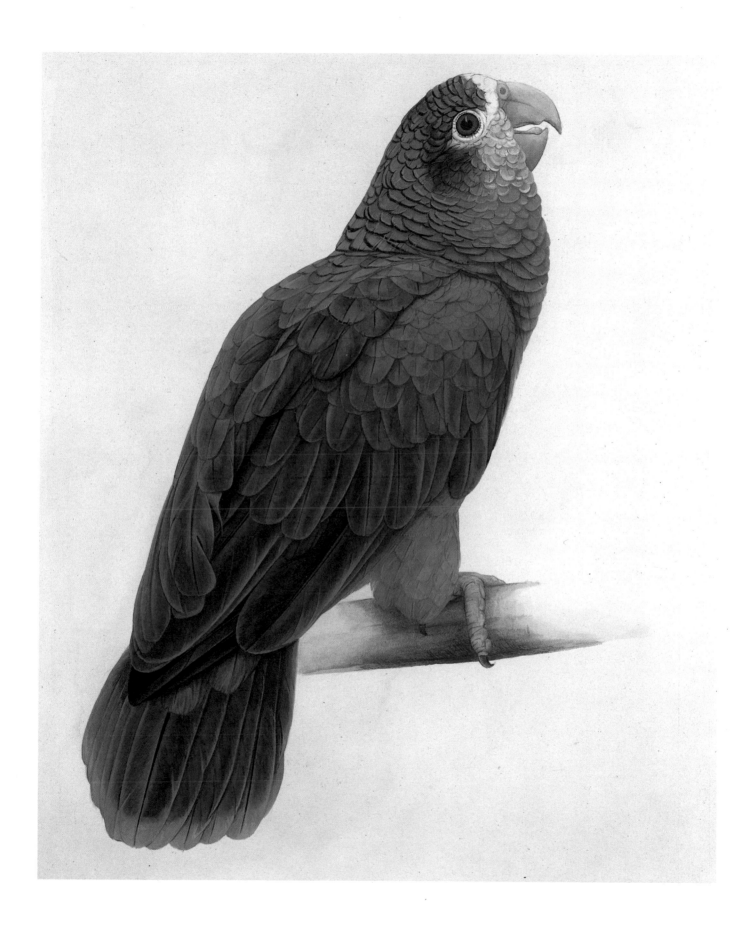

louisa chase

bramble

1980

oil on canvas

182 × 243.8 cm

Louisa Chase has said of her work that it is 'a kind of psychological cubism in that everything is splattered with a different kind of organization' (New Museum, New York, 1980). Like the Cubists, too, she maintains a central stability partly through preserving a distinctive iconography. But whereas the Cubists went in for guitars, wine-glasses and a general café ambience, Chase plays again and again with natural and personal images. *Bramble* shows us her habitual hedge of thorns, curving and highly decorative, but nevertheless a barricade. Here too are her ranked fir trees, with their jagged edges and sinister interior pathway, a visual cul-de-sac that she frequently represents in the form of mountain abysses and precipices. Most revealing of all, here is her pair of folded arms, closed in on a headless and thighless torso. In other works, the folded arms may be paired with isolated hands, reaching hopelessly for contact, and the sense that these arms are folded against something is implicit here also. Perhaps their position suggests an ego enclosing because of the disturbed red of the obtrusive background. In this rumpled and anxious brightness, arms without head or lower body may well seem defensive. There is nowhere within the picture for escape: the brambles form an implacable block to one side, and the sinister firs open their sly arms only to a narrowing gap that has no seeming exit. Both images are deceptive, too. The trees seduce with an apparent pathway, the thorns sprawl in an elegant parabola of pale and tidy flowers. What can one do? Fold the arms and wait. One hand grips the other arm with self-contained patience. Since Chase has gone on record as saying that her work always springs from an actual experience, visually recalled and made permanent, this sombre statement of relived emotion has a stoic bravura which invigorates. Far from being self-seeking, as one may have wondered, it is vibrant with a colourful independence. If the Cubists looked at natural reality from all angles and fashioned a synthesis that kept each angle present, then Chase makes a synthesis of an emotional reality, showing us both her pain and her courage, both present, both life-enhancing.

maria chevska

not drowned

1984

oil on canvas

91.5 × 76 cm

Landscape, Memory and Desire, in which *Not Drowned* appeared, was an exhibition of work by six painters who, according to the selectors, shared a belief that 'painting not only can, but should, evoke reminiscences, reminders of real experience', for which nature is the supreme metaphor. Maria Chevska, like the other five (one of whom, the only other woman, was Thérèse Oulton – see page 82), was seen as offering us 'mirrors' in which 'we sense and recognize our own aspirations, our own fears and dreams and, ultimately, our own bodies.' Again, 'What do we experience' – and this is particularly applicable to Chevska's work – 'but a sense of possibility, an awareness of desire, which may achieve fulfilment or sublimation?' *Not Drowned* is a glowing affirmation of fulfilment, of a hope that refuses to be 'quenched by many waters'. The curve of the woman's thigh suggests that she is riding the waters, yielding to their force and thereby taking into herself potential death – but transforming it. She is dyed the same radiant hues as the waves around her, hues that do not come from external observation but from an inner certainty. Chevska confesses that she detects in her work 'an underlying anxiety', but also 'a faith in the enormous inner strength a woman can command'. In conventional terms this woman appears to have no face which we could take as a gentle suggestion that this vulnerable creature is not 'recognized', not seen in her personal dignity. Only her body is visible, adrift in a passionate sea, jostled by flotsam and mysterious sea-creatures, deprived of comfortable land-based securities. Yet, despite everything, the body's posture, the colour's bright affirmations, both declare that she is 'Not Drowned'. We might, perhaps, read the massed shapes on the horizon line as a house, with a door shut now but potentially open. Yet the woman is not gazing with desire in that direction. Her desire is more inward, a desire that depends on no outward rescue for its fulfilment. Chevska speaks of women artists having 'an urgent need to comment on the world, or explore their own consciousness'. The woman in *Not Drowned* becomes a self-portrait of woman as artist, taking into herself the rich ocean of colour and, by yielding to it, creating from it a vehicle for the spirit. To misquote, Chevska is 'not drowning, but waving'.

eileen cooper

safe and sound

1985

charcoal on paper

76.2 × 55.9 cm

Tamar Garb's very timely book on women impressionists (Oxford, 1986) shows them producing mostly 'feminine' images; the circumscribed world of their times left them little option. Since then, women artists have tended to react against these stereotypes; however, since any artist can only create from within his or her own context, for many women this context will include childbirth and domestic intimacies. What makes Eileen Cooper so remarkable as an artist is the power and truth contained in her pictorial musings on the birth of her son. What it means to be a mother, to unite with another human being to bring into the world, and be responsible for, a child: all this potentially sentimental imagery is handled by Cooper with a dignity and boldness that seem to give us access to some fundamental mystery. *Safe and Sound* shows both parents apparently almost breathing the child into existence. Small Sam (her son) is fenced away from danger by his parents' kisses, and their sheltering hands hover beneath him, a safety-net. Yet what giants the adults are to the new-born human! Sam is, as it were, scaling the cliff-face as he hangs on beneath the jutting overhang of his parents' noses, and their eyes, gazing both at themselves and at him, gleam darkly from the recesses of caves far above him. We are made very conscious that the child is small and frail, a 'tiddler', as one of her other works calls him, plump and healthy, but wholly dependent. Yet he is 'safe and sound', because he is loved. There is even a hint that he is truly 'sound', a healthy baby, in that love holds him so safe. Even a third meaning of 'sound' occurs to us: all the mouths here are closed, it is a silent image, yet in the silence the mutual confidence of love is all the more clearly heard.

Cooper's medium here is drawing, charcoal on paper, the strong black lines strikingly confident in their sparse clarity. Asked once whether she felt nervous in a mainly male (art) world, she could innocently reply that she did not feel she was 'competing with men'. She added: 'I feel what I am saying is very different.' She is right, but only a very original woman can dare to be so conventional, or, rather, to seem so.

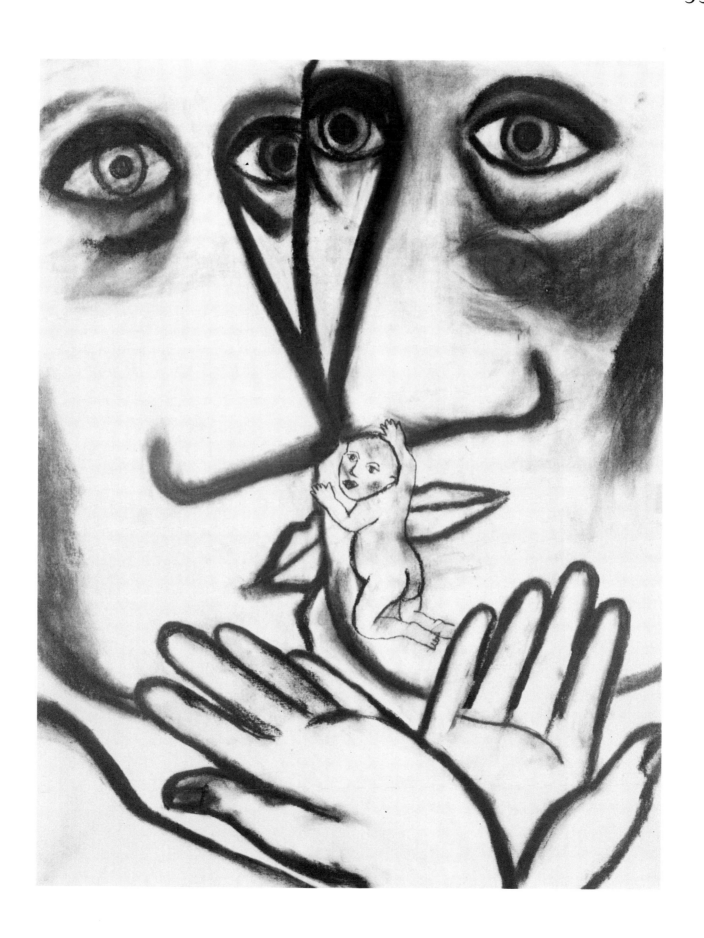

louise fishman

cinnabar and malachite

1986

oil on linen

127 × 99.1 cm

Louise Fishman comes from a Jewish family from Eastern Europe. Her grandfather, a scholar of the Talmud, was forced to leave Russia, went to the Argentine, and became a gaucho. A friend recently pointed out to Fishman that this could be a good description of her: 'a Talmudic scholar on a bucking bronco'. A passionately committed Abstract Expressionist, Fishman combines the formal discipline of a scholar – hers is a very severe art, rigorously controlled – with a sort of intense exuberance that throws her around like the cowboy on his bronco, but never unhorses her. *Cinnabar and Malachite* has the pure emotional beauty of an abstract art which has refused all the engaging shortcuts of readable iconography. The title admits us no latitude in interpretation. Few artist practise so profound an otherworldliness as Fishman. The meaning of the work is the work itself: the brush and palette knife have worked and reworked its surface. Every least marking has its significance, but it is never one that can be spelt out, laid before us, made 'ordinary'. When Fishman, again brooding on her grandfather, says she has come to recognize within herself 'a very strong religious or spiritual side', she makes the immediate application: 'I think it has to do with the way I approach painting.' *Cinnabar and Malachite*, with its strong plunges of line and colour, its fierce, austere horizontals, its diagonal sweeps that are so inner-directed, indicates in what way her work, superficially concerned with colour contrasts, is fundamentally an act of worship. Even the colours of the title carry a deeper significance. They roll with a Miltonic largeness, and we would be foolish to take them as poetic synonyms for vermilion and blue–green. 'Cinnabar' can denote 'red mercuric sulphide', with the suggestions of both metal and the divine messenger, Mercury. The word itself comes from the Arabic *zinjifrah*. 'Malachite' is a mineral, the basic carbonate of copper, and its name derives from the Old German word for a mallow leaf, *malache*. The sound makes an implicit association, too, with the prophet Malachi. Are we meant to ponder all this? Only if it helps us to see with the 'feeling of immediacy' that Fishman seeks.

jane freilicher

in broad daylight
1979
oil on canvas
70 × 80 cm

Fairfield Porter, the realist painter and close friend of Jane Freilicher, has said that there is no essential difference between representational and abstract art: both are equally 'real'. This is a belief dear to Freilicher. The ostensible subject of her work is nearly always the view from her studio windows, usually seen behind a still-life arrangement, and unless we compare what is actually seen in different works, whether from her New York City windows or from her rural studio on Long Island, we can imagine we are looking, with her, at 'what is there'. But she does not always 'see' the same realities; 'what is there' varies according to her inner impulses and moods. She has suggested that 'a painting is an exploration of how one sees, a representation of the process of seeing'. She quotes the art historian Fromentin's view that 'painting is making the invisible visible', and Constable's that painting is 'another name for feeling'. And she adds, 'Your reality is not my reality; and, in the end, my intentions may not matter as much as some unconscious flow I don't fully control or comprehend.' These are useful hints towards a true response to these luminously beautiful pictures which it may seem so simple to understand. Freilicher clearly delights in confounding outside and inside. Her glowing flower-bunches, like the table on which they stand and the casual array of household goods around them, are bathed in the same radiant air that floods and caresses the garden and meadows. Distant waters, far sky, immediate shrubbery foliage, a foreground scattering of plums: all is somehow almost mystically united by the sweetness of the gentle light. The emotions from which her images arise are never dark. Freilicher, rather like Matisse and Bonnard, invites us into a world where joy is always possible. It is, in a sense, not quite 'our' world, with its darkness and disease and lack of experienced unity, but it is no less real. The magic of a painter like Freilicher is that she convinces us that the paradise-world is in fact more real, more in tune with the utmost meaning of reality, than a dimmer vision would claim.

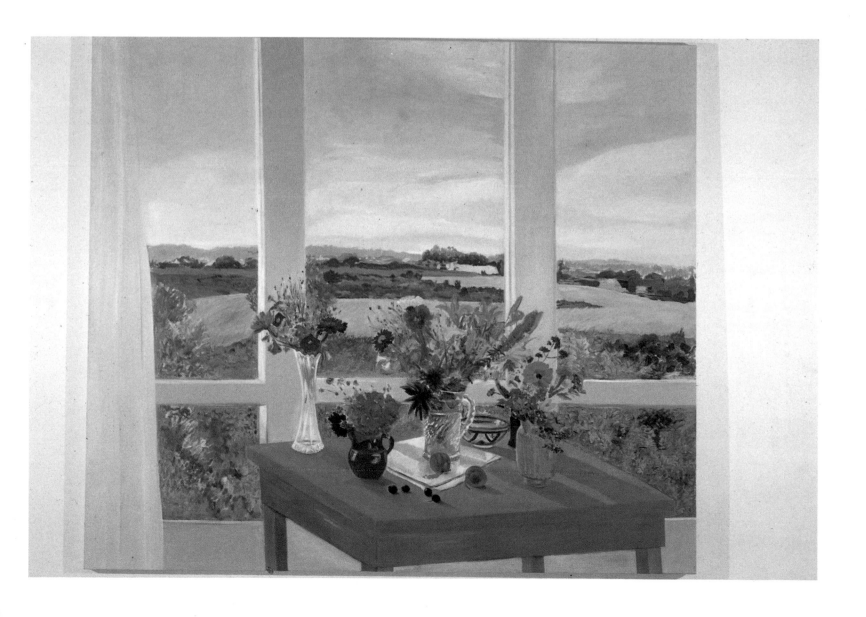

jean gibson

breakout III

1985

fibreglass, tetrion, herculite
and p.v.a.

45.7 × 91.4 cm

About seventy years ago the great Russian Constructivist, Kasimir Malevich, astonished the artistic world with his *White on White*. Like a huge square ikon, it presented the spectator with a completely monochrome surface; it was all white. 'The square', explained Malevich, '= feeling, the white space = the void beyond this feeling.' It was precisely this sense of intense emotion silently made visible in the purity of monochrome that made the work such a breakthrough. Jean Gibson claims Malevich as her spiritual father, and though she does not dare to call her wall sculpture 'Breakthrough', she does entitle it 'Breakout'. She is, of course, by no means the only artist to develop the insights of the Constructivists in this way. A recent exhibition on the theme of twentieth-century white monochromes included some of the most famous of contemporary painters. But what distinguishes Gibson's work, and deepens the paradox of the austere form and the explosive emotional content, is that her work is far more substantial and physically demanding than merely putting brush to canvas. She creates her sculpture from dense and hard materials, wresting them into submission, pressing them out, waiting for them to set, sometimes even incorporating stainless steel. She is, essentially, pressing her work out of herself. With the starting-point of a natural image – in the case of *Breakout* the ruffled surface of a pond – she transforms her image into a visible expression of her own deep feelings and desires. Her titles are deliberately neutral, and this is partly in order to leave the onlooker free to enter into her forms and seek therein a personal meaning. But one suspects it is also partly because Gibson herself understandably cannot narrow down a great breadth of emotional content by verbalizing it. There is a hint of expression, though, since *Breakout* may appear to be on the verge of literally breaking out, bursting through the surface, entering into another dimension, yet the passion is always contained. As the sunlight moves across the surface – an effect that, very sadly, it is impossible to reproduce in a book illustration – the changing pattern of shadows and brightness 'speaks' to us with a quite ineffable power.

nancy graves

cantileve

1983

bronze with polychrome
patina

245 × 170 × 135 cm

At every stage in her career as a painter and sculptor Nancy Graves has confounded the critics. She began in the sixties by deciding to concentrate on a specific form in order, she said, to be free to 'investigate the boundaries of art making ... to explore and invent'. Her extraordinary choice of theme was the Bactrian camel, and in 'learning' the camel from within to without, Graves certainly did launch herself on a triumphant course of technical and spiritual freedom. No other sculptor creates such superbly unique and paradoxical images, at once dazzlingly beautiful and almost eerie in their complexity. Her method is as unique as her effects. She casts directly into bronze, without preliminary drawing, let alone modelling, and the half-unforeseen result of her work adds to her communicated sense of wonder and excitement. She uses for these direct casts a weird array of found objects, though 'objects' is insufficiently respectful for the reverence with which Graves salvages pods, leaves, shells, old fans, ferns, farm tools, vegetables, wooden scissors, etc. Collectors are said to enjoy trying to identify the original components in her works but, as is clear from *Cantileve*, this is a relatively superficial pleasure. The real joy of this gigantic work, over two metres high, is the miraculous marriage of lightness and weight. It seems to float, airily suspended, both supremely confident and infinitely frail. Openness and lightness are the two qualities Graves most admires and strives to embody, adding that she is 'constantly trying to realize the visually impossible'. What makes the 'impossible' possible is above all her use of colour. She burns her hues actually into the bronze with a blow-torch, as if somehow painting in the air with solid colour. *Cantileve* is therefore an expression of a spiritual fullness, a radiant reality that accepts all aspects of its being and glories in them. 'When I am weak, then I am strong', said St Paul. Graves, who has declared 'I want it all', sweeps us up in a cantilevered parabola that is simultaneously weak and strong and sets us free to have it 'all' by its exhilarated truthfulness.

maggi hambling

the search is always alone

1981

oil on canvas

54.6 × 53.3 cm

Maggi Hambling, like Alice Neel (see page 78), is primarily a portrait painter. From the autumn of 1980 to the spring of 1981 Hambling was Artist in Residence at the National Gallery in London, and during that period of great personal growth she saw at the theatre a one-man show by the great actor–clown, Max Wall. Hambling was fascinated, recognizing in Wall 'the true face of the sad clown', possessing 'that power I can only call magical to make one laugh and cry at the same moment'. Max Wall went on to play Vladimir in Beckett's *Waiting for Godot*, and throughout these years he frequented Hambling's studio, becoming her friend and sitting for a series of powerful portraits. Some show him as the lonely and beleaguered clown, others, of which *The Search is Always Alone* is one, depict him in his *alter ego*, Vladimir. The Godot portraits are less intimate than those of the unadorned Max, but essentially both sets carry the same charge of passionate search, courage and gaiety against the odds. Like the clown himself, they are embued with a tragic humour. In *The Search is Always Alone* Vladimir–Max is remembered as the sole living creature in the bare, barren round of existence. He scuffles hopefully forward, seemingly unaware, or, more exactly, refusing to be daunted by his awareness of how cold and isolated his world is. The stage is shown as egg-shaped, possibly alluding to the significance the egg holds for Wall and Hambling. (He conjured for her with an egg, and later gave her a glass egg to keep.)

Hambling dislikes having her delicate imagery analysed, holding with Wordsworth, perhaps, that 'we murder to dissect', and certainly the suggestions made implicitly and poetically by the magical egg and the small human figure within its ambit are too lyrical to be expounded verbally. Although Wall is so minute in the vastness of the canvas, he is not swallowed up by his surroundings. The strange metallic backdrop, moonlight glittering on the inhospitable trees, the social wilderness in which Beckett sets his play, only serves to emphasize the courage and individuality with which Hambling empathizes and to which we respond.

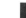

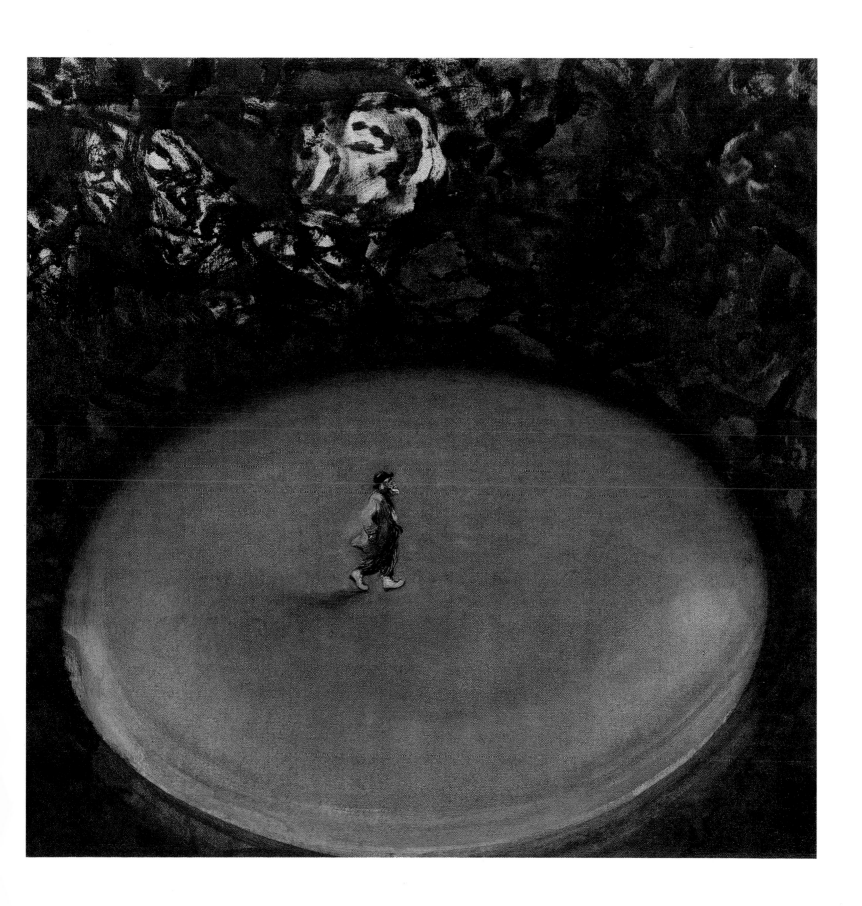

gwen hardie

cowardice

1985

oil on canvas

220 × 160 cm

It is rare for a very young artist to be both original and unselfconscious. Gwen Hardie is still in her early twenties, yet she seems to have a spontaneous understanding of how best to make visible an artistic presence. Her forms are all vast, filling and overflowing the canvas, yet they are clearly her own forms, and nobody else's. She invites no narrative interest. Her most obvious characteristic is the typically Scottish virtue of reticence. This gigantic head is certainly correctly entitled *Cowardice*, but we should note the careful use of the abstract noun. We are not presented with 'The Coward', even if the head, stiffly turning, the slanted and frowning brow, the pursed mouth, the rigour of the unwilling pose, all demonstrate a fear and a reluctance. In her objectivity, however, Hardie leaves us no story-telling escape-route. That mouth, that fearful stiffness, that is our own. Cowardice is common to us all, an element in our psychic make-up with which we all have to deal at one time or another if we are to become adult. Hardie forces us to contemplate this by the hugeness of her image: 220 cm (nearly seven feet) high, yet the canvas cannot contain our *Cowardice*, as it were; it surges up into the formlessness beyond and beneath. The head is only vestigially present in a bodyless lack of clarity – a vague, dim face confronting our own vagueness. Only the mouth is fully defined, with a sharp beak of nose directing our attention to it. Closed mouth suggests closed heart: the visual beauty of the soft colour contrasts painfully with the far from soft defensiveness of the form. The hair, as subtle in its delicate modulations of tone as an Abstract Expressionist could desire, clings tightly and confiningly to the bones of the skull. We should not let our cowardice inhibit us from response, suggests the image: the quality of life depends on courage.

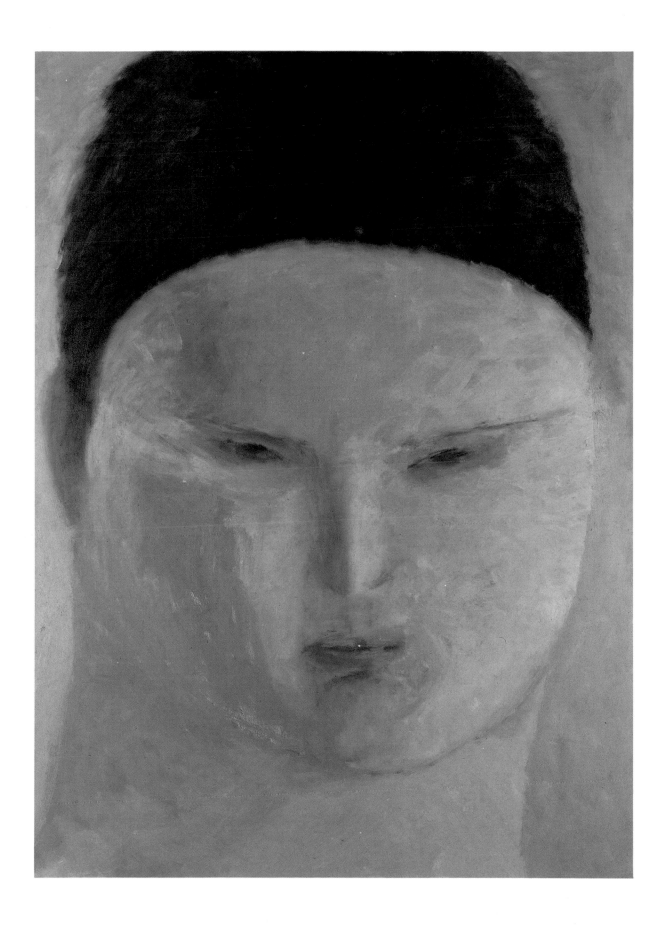

shirazeh houshiary

ki

1984

copper

160 × 400 × 40 cm

The critic Lynne Cook has suggested that when we see *Ki* our first response is to *think* (Cook's italics) that we know it; but we are uncertain, and feel impelled to examine it more intently. This is a tribute to the delicate certainty with which Shirazeh Houshiary gives credible form to a poetic vision. A native of what was once called Persia, she is steeped in the myths and poetry of her nation. In her earlier work she expressly drew upon these riches, invoking Sufi parables and even calligraphy and limiting herself to materials such as clay and straw, where there was an obvious primordial relationship. Her work is now, to some degree, less particular and less personal, though her earlier aim remains: 'I want', she said, 'to make you dream because that's the only way I can communicate with this language that I am using.' If her language strikes us as increasingly difficult to interpret, she still desires eagerly to 'communicate'. Since human beings are fearful, we may shy away from her invitation to 'dream', even though we may in our hearts know that rationality can never 'save' us. When we dream, we have to let go of our waking defences, our tight hold of logic. *Ki* forces us to let go, to wander into a dream. If we resist we can always write the work off as the incomprehensible baby-talk the word 'Ki' is intended to suggest. Not all sounds are words; not all communications can be confined in the limits of a language. *Ki* is roughly twelve feet long and four feet high, a sprawling mass of darkly gleaming copper that scorns a pedestal and insists on entering into our private space. Like an axe-head become animate, like some exquisite artefact whose meaning we alone do not know, it beckons us out of our ignorance into its world of dream. The creature refuses our control, and we cannot ignore the suspicion that it will overpower us. In this, Houshiary presents us with a visual parable of existence. She sets it before us in its untamed power, yet the closer we look, the more secure we shall become. The potential threat is defused by the beauty of art, as the vast expanses of copper are lovingly burnished by the artist's hand. *Ki* is about the freedom to enter into mystery unafraid.

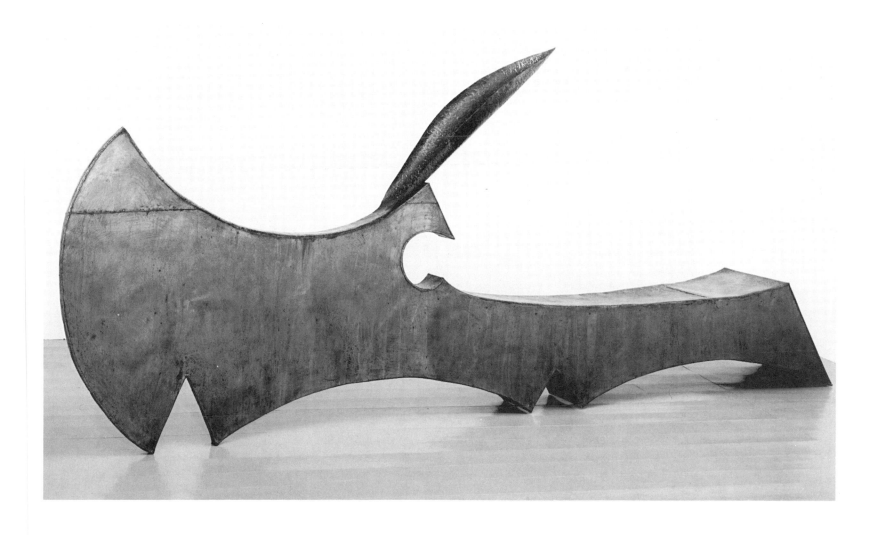

edwina leapman

dark green painting
1986
acrylic on linen
168 × 183 cm

Agnes Martin, perhaps the greatest living contemporary painter, has said that one never gets tired of looking at moving water. ('There's nobody living who couldn't stand all afternoon in front of a waterfall.') It is this comparison – looking at water, gazing into waterfalls, contemplating the sea – that spontaneously occurs to us when we see Edwina Leapman's paintings. *Dark Green Painting* can certainly hold the attention for a long period, even on the printed page. There are hidden colours, an elusive pink that only reveals itself to the attentive eye; there are almost imperceptible brush movements, soft clouds that seem to drift to and fro upon the surface and to swim up gently from the depths. Unforced depth is Leapman's special gift. She has said: 'The surface is both above and below', a very profound observation. Whereas the abstract artist Frank Stella has insisted 'what you see is what you see', meaning that his surface had no hidden depth and was not meant to have one, Leapman achieves the very opposite. 'The movement is slow', she adds; but the point is that, like the sea, or like life itself, *Dark Green Painting* has 'movement', and contemplating it is an act of meditation. Alan Green, a Minimalist painter in a tradition very different from Stella's, has said of Leapman's art: 'Each work exists as a demonstration of human frailty . . . Their strength lies in the doing. These paintings actually have to happen' – he is thinking here of the immense demands such exacting and sensitive work makes on the artist, and Leapman is physically frail – 'the time actually has to be spent and mistakes actually have to be made'. Green regards these 'mistakes' as very significant, the potential manner of arriving 'at the condition of freedom where art can exist'. If the making of a work demands such ascetic concentration, it is not surprising that this manual prayer, as it were, soaks deep into the canvas. When Leapman tells us: 'For me painting is about nature', we may be initially confused. But she goes on: 'Not the representation of appearances, but the allowing of natural forces from within oneself to work in accord with the outside world.' In a sense, all art aims to do precisely this.

judith linhares

red sea

1982

oil on canvas

182.9 × 121.9 cm

In 1982 the New Museum in New York held panel discussions on Figuration, and Judith Linhares was one of the panel members. She had recently moved to New York from the West Coast, and was clearly puzzled at the stress given to figuration as 'new', when she and others had long been seeking artistic communication through a highly individualized use of figure painting. Linhares sees painting as 'a language', one that she seeks to speak in 'an increasingly articulate manner'. Her concern is primarily, though, with the content of her language, and *Red Sea* (which appeared at the Venice Biennale in the year it was painted) does not use content as a vehicle for artistic form but as an end in itself. Content is 'the end'; Linhares is making visible to herself and to all of us something profoundly personal and of weight. What this exactly is, is not clear, nor is it meant to be. *Red Sea* is poetry, where the mystery of what is expressed is essential mystery, springing from too deep in the human psyche to permit of more explicit form. We see a naked woman, reduced to almost skeletal outline, alone and transparent in a red boat on a red sea. But what she bales from her boat is not transparent: the thick white deluge of water, initially blood-red, baled from some container as skeletal as the woman herself, suggests itself as somehow integral to her – her tears, perhaps? The rich waters swallow them up; they fall upon and seem to irrigate a swaying underwater tree, seaweed or coral, and they seem to activate the giant octopus that is the only other inhabitant of this magical world. Its long, graceful arms soar up above her unregarding head, while the paddle that is her only hope of escape lies dangerously at rest upon the waters. The biblical Red Sea was an image of escape through miracle, and not without sacrifice: the Egyptian in man has to be drowned. However personal the iconography of Linhares painting, it impresses itself upon us as integral to our own lives, too. When she declared at the New Museum that she did not see figuration and abstraction as being incompatible, she went on, 'I think of abstraction in terms of transcendent experience, in a general way, and . . . realism as more intimate'. *Red Sea* is both.

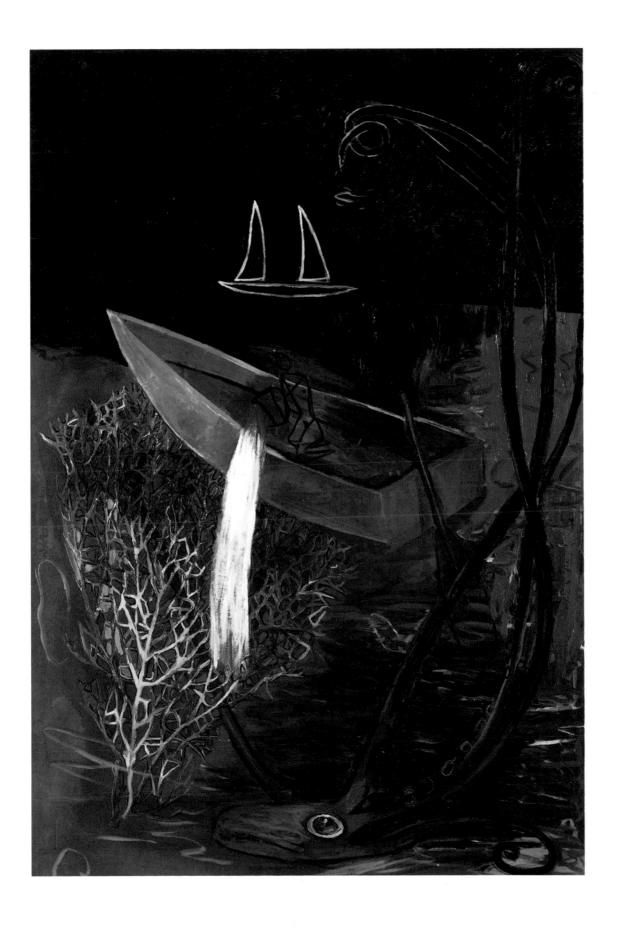

agnes martin

white flower

1985

acrylic and pencil on canvas

182.8 × 182.8 cm

Agnes Martin is opposed to any attempt to reproduce her work, and we can see why; it must be rather like trying to make a tape recording of silence. Keats has warned us: 'Heard melodies are sweet but those unheard are sweeter still.' Martin offers us the visual equivalent of unheard melodies, of the 'ditties of no tone' that Keats asks to be piped to 'the spirit'. All her work addresses this 'spirit', so it is not unfitting to realize that we can really see *White Flower* only from within, from 'the spirit'. At first glance, Martin can seem to have painted nothing, merely to have etched slight and tremulous pencil lines against a faintly modulated background. The lines are gently but strongly horizontal, which some see as a symbol of the vast spaces in which she has always desired to live (both bodily and spiritually.) She grew up amidst the immense prairie lands of the Canadian west, and for most of her adult life she has chosen to live in the immense deserts of the American south-west. But this material fact is most of value in helping us to see what matters to Martin: solitude, individual desire, interior space, joy. A lecture she gave at Yale University some years ago began: 'We are in the midst of reality responding with joy.' Only one who is truly free can receive this joy. Later in the lecture Martin says: 'Joy is *perception*. Perception, reception and response are all the same . . . all awareness of reality.' In *White Flower*, nothing seems to 'happen', as it were. The faint lines flow silently to the extreme margins (all her paintings are six foot square in format), eternally present without confinement to a definite image. Perhaps another Martin quote is helpful: 'My paintings have neither objects nor space nor time nor anything – no forms. They are light, lightness, about merging, about formlessness breaking down form.' They are radiantly beautiful, drawing us into their joy and letting us see it is not theirs, but ours.

> The frailest stems
> Quivering in light
> Bend and break
> In silence.

Martin comments on her poem: 'It is what is known forever in the mind.'

louisa matthiasdottir

house and sheep
1982
oil on canvas
35.6 × 53.3 cm

Because Louisa Matthiasdottir was born in Iceland, critics have been eager to trace a likeness to Munch. Nothing could be less true: she is blessedly free of Expressionist drama, without a touch of modern angst and excitement. (Asked herself about Munch, Matthiasdottir replied briskly, 'Well, I like Matisse. I know that. And Titian. Is that enough?') The matter-of-fact simplicity that is a personal characteristic is reflected in her work, but the clarity of what she shows us must never be confused with dispassion. Matthiasdottir is richly emotional as an artist, as were Matisse and Titian, but like them, she expresses this richness in her colour. Controlled emotion, concealed passion: these are what give her work its radiance and vitality. *House and Sheep* is a typical title: sheep, horses, riders, mountain, grass, lake, a small village, these building blocks of an Icelandic scene recur repeatedly. In one sense an exile in that she and her husband live in New York, Matthiasdottir paints without nostalgia. If she speaks of her native land with much love, that happy country where 'the atmosphere is very clear', without 'haze', 'very sharp, almost hard light', and where, because it is 'volcanic, it has many more colours. The lava is red and black ...' and where, defect become virtue, 'there are no trees', so that in Iceland one can 'see beyond ... get a sense of the horizon ... for great distances', then this love is for sharing. She re-creates for us that bright and innocent world, still hers, still enjoyed, still seen as a symbol for a granitic inner strength and spiritual harmony. The sheep and the landscape in *House and Sheep* are together part of a greater whole. The pure jutting expanses of colour that are hill and lake, with intense mountains behind and smokeless sky above, are not there as a setting for the animals, and the sheep in turn, perfectly balanced, with Matthiasdottir coming down firmly on the side of the angels, one black to two white, are not there to adorn their background. Each element has equal weight, interlocking seamlessly to present an unromanticized Eden. The absence of all clutter is significant, and the directness of an unself-centred delight. We see through Matthiasdottir's eye 'made quiet by the power of harmony'.

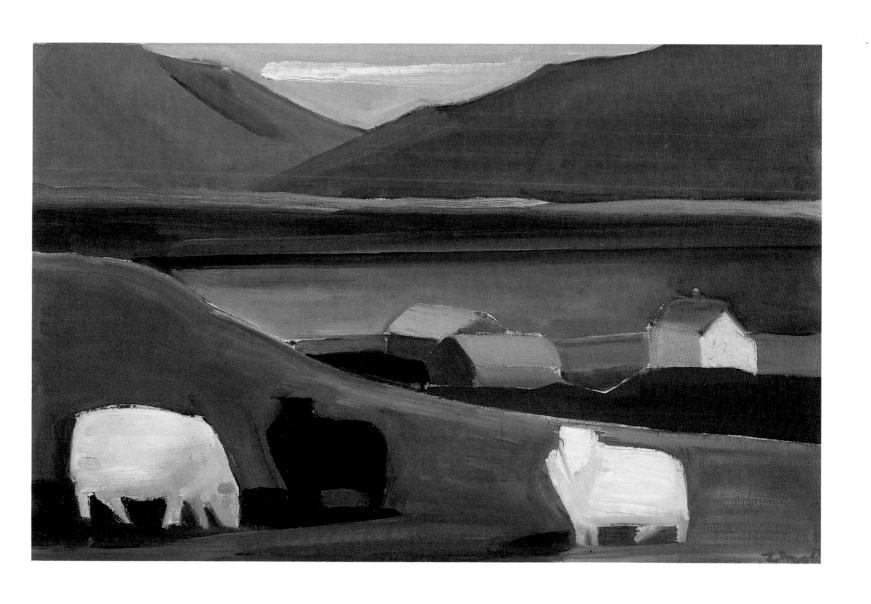

melissa miller

owl in sheep's clothing
1985

acrylic on paper
55.9 × 76.2 cm

Painters who take the animal as their theme, like Melissa Miller, can adopt various approaches. They can concentrate on the animal in itself, as Stubbs did; or they can go further, like Franz Marc, who tried to paint the world as an animal would see it; or they can concentrate on man, using the animal as a metaphor – 'People can anthropomorphize into animals', as Miller expresses it. She claims to like the last two of these options and to see both as 'possibilities'. Yet, in fact, Miller's art is unlike any other, in that she first makes a thorough, almost Stubbsian study of an animal, and then uses it, not so much as a metaphor or as a transformed human, but as a rather subtle, hermetic making-visible of her own private experience. It is not 'man' she shows in her creatures, and not 'woman', either: it is Miller. Exactly how it is 'Miller' is another matter, and, of course, any deeply experienced artistic image once completed becomes common property. Miller hands over to us her experience and her vision, for us to use for our own self-awakening.

Owl in Sheep's Clothing is one of a series of disguise pictures that Miller painted throughout 1985. There was *Lioness in Zebra Skin* and *Baboon in Leopard Cape* and *Rabbit Parading as Fox*, to name but a few. All have the same rather lurid brightness, a sinister glare that focusses the attention and forces us to confront something. Those who wear the disguise are predators like the wolf or, as here, the hunting owl, or they are the preyed upon, like the rabbit or baboon. On either side of the fence, it would seem, victim and victor need a disguise. But in either case, they garb themselves in the skin of a dead enemy. This owl, so terrifying in its implacability, is draped, unconvincingly, in the tattered fleece of the sheep it has killed. It is as though Miller – and the person who shares her vision with her – is only free to pursue her goal, a necessary goal (since the owl must hunt to live) when there is the reassurance of having already been successful in the past. Even though the owl is able to fly in freedom, the weight of its need for reassurance keeps it low, with a troubled sky reflecting the spirit's turbulance. We can sense the 'meaning' without being able to spell it out.

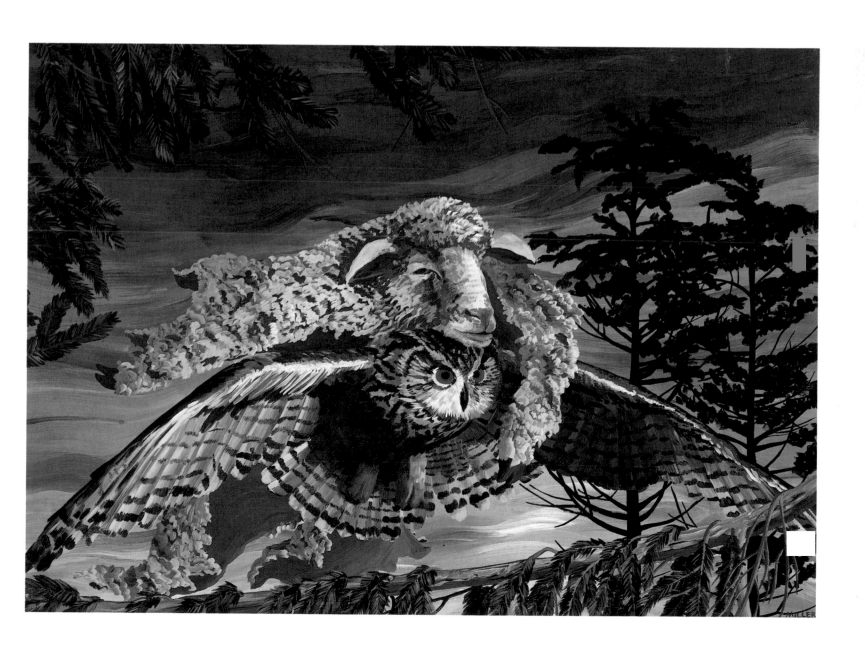

lisa milroy

shoes

1985

oil on canvas

176 × 203 cm

Andy Warhol and Campbell's soup cans, Wayne Thiebaud and trays of sticky cakes:we have become used to the interest contemporary artists take in the massed array of similar objects and the wry comment on our society that is implicitly made. In this context it becomes fatally easy to misread Lisa Milroy and see her work as metaphoric. Her motif is always basically the same – articles from common life, such as books, sunglasses, skirts, trousers, shirts, or the more rarefied postage stamps, Roman coins or Greek vases – and she spreads them out in ranks, essentially undifferentiated. They sprawl freely, without a confining background, and a casual eye may well see her as intending to 'stress the power of the medium over the object'. Milroy herself has expressly denied this, and *Shoes* is in no sense an exercise in artistic power conceptions. These objects, the generic shoe – or, rather, the generic shiny, black, woman's shoe – are not possessed by Milroy. They are not 'her' shoes. She neither controls the pairs of shoes nor scrutinizes them so that they control her. These are not shoes observed as shoes, either for use or for decoration, but shoes seen as shapes and sights. Almost abstract shoes, the pure geometry and pattern that the idea of shoe arouses in Milroy's imagination. She has contemplated the variety of shapes and tones a repeated depiction of black shoes will yield, and has taken intense delight in exploring this variety. Although one shoe is identical to the next (since they are not actual shoes but conceptual shoes, pictorial extrapolations of a previously observed and now recalled to mind shoe), light gleams most seductively, now here, now there, as the long, sinuous shapes are investigated in every posture and pattern. They lie in a no-man's land of pallid background, so that all our attention is free to enter with Milroy into the visual delights of her imaginings. Completely without fantasy, these silent shapes have a compelling elegance that is all the more powerful for their material simplicity. Milroy does not have to seek far afield for what is fascinating, and she has no need to invest it with symbolic trappings. She shows that to be, and to be pictured, is revelatory for one with eyes to see.

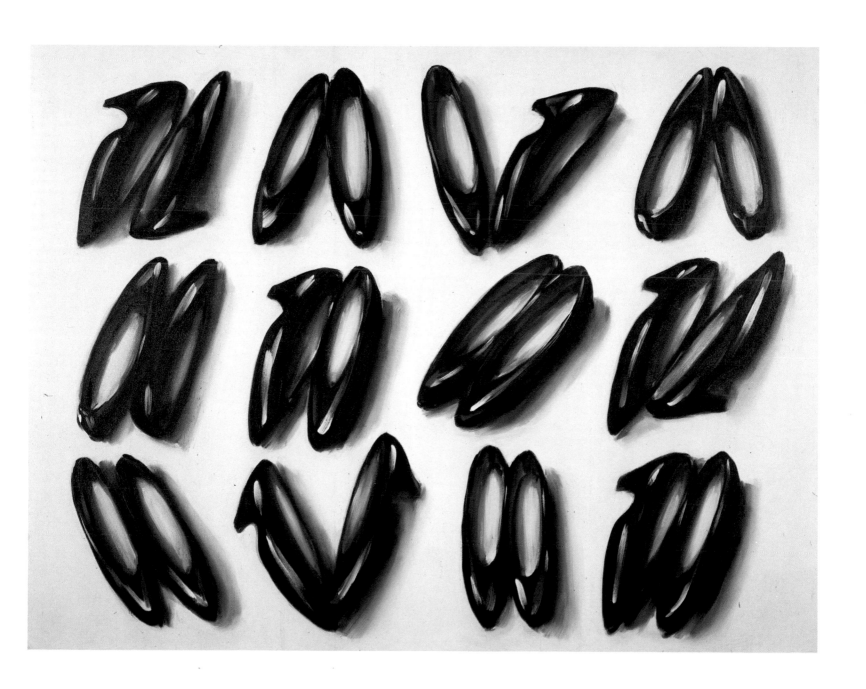

joan mitchell

faded air I

1985

oil on canvas

diptych, 260 × 260 cm

Speaking recently of how she had been very ill, and unable to paint, Joan Mitchell described the happiness of coming back to life. This feeling is intimately connected with her paintings: in a sense, they are all about being alive, being fully open to life's joy. She has said that she wants 'to paint the feeling of a space. It might be an enclosed space, it might be a vast space', and this space is another expression of the experience of living: 'Painting is a means of feeling "living"'. *Faded Air I*, so exquisite in its poignancy and beauty, is one of the pictures she painted that were inspired by dying flowers. 'Sunflowers are something I feel very intensely. They look so wonderful when young and they are so very moving when they are dying.' Her sense of life is profoundly imbued with her sense of death. For Mitchell, painting does not dismiss the dreadful truth of our death, but sets it in a timeless dimension. *Faded Air I* is a diptych, and the stern geometry of the double panels supports and frames the lyric fragility of the drooping, cobwebby brightness of the image. She has not painted 'sunflowers' in any realistic sense, but she has opened up for us a place of tender happiness, where the essence of sunflowerness is made present. Blake called it a flower 'weary of time' that sought ever 'the sweet golden clime/Where the traveller's journey is done'. That is what Mitchell also sees. She speaks of painting as never ending: 'it is the only thing that is both continuous and still'. And she adds, thinking of the 'space' her work makes possible for her, and for us: 'Then I can be very happy. It's a still place.' This stillness and happiness, of which we are so conscious in *Faded Air I*, has something to do with what Mitchell calls 'non-self-consciousness. When I am painting, I am only aware of the canvas and what it tells me to do. I am certainly not aware of myself . . . I am in it. I am not there any more.' Her reference to 'what the painting tells me to do' is mysterious, and she admits that there is no 'meaning' that can be put into words of what the picture is 'saying'. Rather like poetry, it is its own meaning and one can only contemplate it and receive this meaning on a level deeper than the conceptual. The picture itself, she suggests, 'tells' us how to see it.

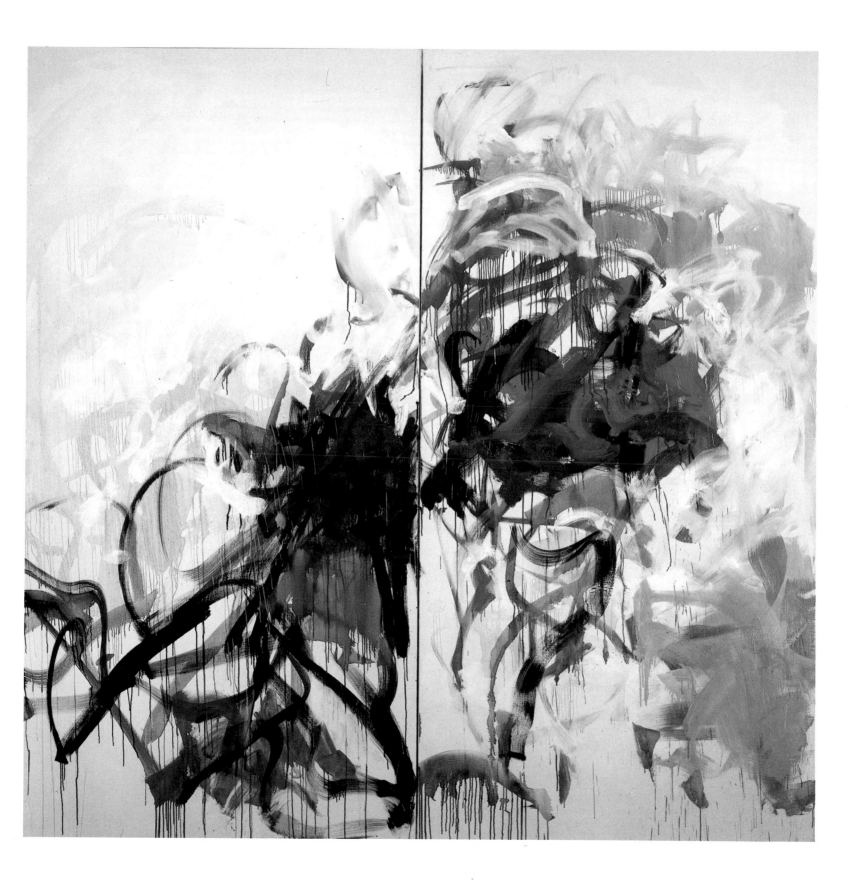

Some abstract artists give visual pleasure, but only for a time: they cannot sustain it. To say that their work does not seem, in the end, to 'mean anything' is not to imply that a painting can have a 'meaning' that we can extract and analyse. Like the act of worship, the act of art is a spiritual one, incarnated in material form but not thereby made intellectually accessible. But with Mali Morris we are always conscious of what Kandinsky described as 'inner necessity'. Her work has a profound centrality, and it grows from deep within the artist herself. Her feelings about painting, she says, are well expressed in *Epoch and Artist*, the collected essays of David Jones, that lyrical painter whose sacramental approach has clearly influenced her. Jones speaks of the artist's need to love and master an art form, and then he changes 'master' to having 'been mastered by the elusive constraints of . . . art. Otherwise', he insists, the artist 'cannot move us by the images' that art will 'call up, discover, show forth and re-present.' Morris, unlike Jones, is an abstract artist, and her images are not representational. Yet they do mysteriously 'call up, discover, show forth and re-present' not specific material objects, but something more fundamental. She sees her work as 'informed by nature', drawing its emotion and its power from 'having been mastered' by some shape or insight. The shape we find in her latest paintings is the diamond. *Black Diamond Encircled* has a haunting beauty that gently invests the central lozenge with a power of mysterious significance. It is no 'sharp and sided' form (to quote Gerard Manley Hopkins, one of Morris's favourite poets). Even the black is gentle, a smokey and translucent colour that abides tranquilly the more turbulent squares of brighter colour that press against it. The 'encircling' is likewise tender, gentle, undramatic. It plays around the diamond like a halo, not fencing it off from life but quietly radiating an openness, an availability. We are drawn into the infinite depths of the diamond somehow held there for us by the pale halo of light. There is a beautiful sense of being 'centred'. Morris paints slowly: 'The looking takes much longer than the putting on of paint.' We are drawn into this slow contemplative looking.

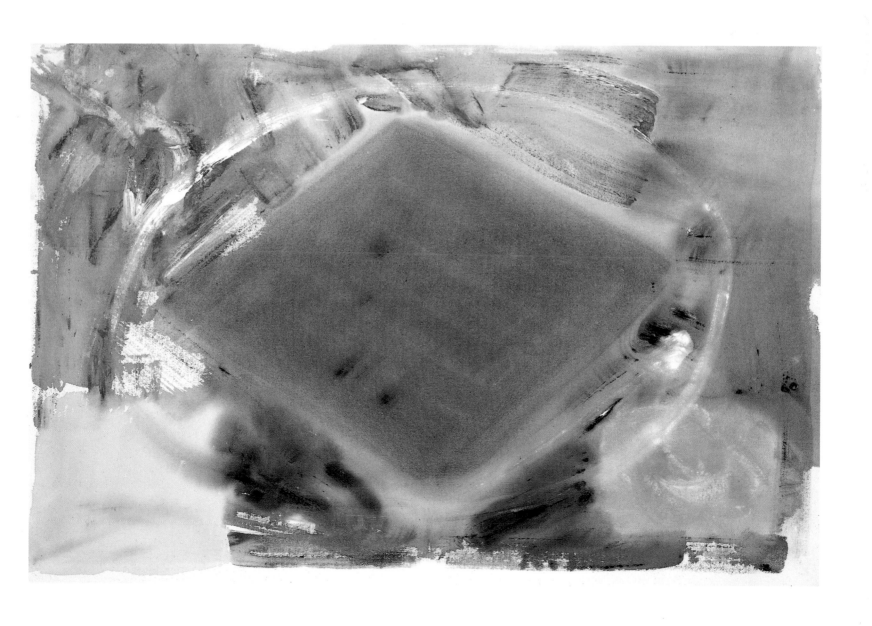

kathy muehlemann

mesmerized
1986
oil on linen
27.9 × 71.1 cm

Perhaps the most obvious reaction to Kathy Muehlemann's work is amazement that it is so small. *Mesmerized* is one of the largest: just under thirty centimetres high and just over seventy centimetres long, and even this still gives it a barely visible presence. We often see most easily what demands to be seen, the big, bright works of art that confront us immediately. Muehlemann does not avoid confrontation – quite the contrary. But we must seek her out, come prepared to be confronted. The mesmerizer cannot lay hold of the restless psyche unless and until there is a deliberate choice to surrender. Again, Muehlemann points out, 'The small size is psychologically contrary. A larger canvas becomes part of the world because it is more referential . . . more profane because it is the size of the things I live or move in'. (She is using 'profane' in the sense of the opposite of 'sacred': 'the different space in a cloister' where 'the feeling of everyday life was condensed; you arrested it out of the normal . . . you were able to claim back some of your own inner space.') She realizes, too, that 'There is a fragility to an image that barely exists. If the painting . . . spread out into the room, its energy would be defused by its dependence on other things, which releases the tension from the image.' An image like *Mesmerized* is both too small and too spatially complex to be either an anxiety to us or an over-simplification. When Muehlemann says: 'I view my works as sites of rest for the viewer and myself' she undercuts any idea of the rest being sluggish repose by adding, 'They're supports for contemplation.' What we are to contemplate is, of course, what gives them their mysterious appeal. The deep and heavenly blue of *Mesmerized* is a pacific ocean, in which the infinitesimal black blips glide in silence. As the eye moves slowly along, the perfect rightness of each one's placing seems to bear an echo of that divine attention to the 'least one' that is voiced in 'Every hair of your head is numbered.' The blue darkens and lightens, the blips cluster and separate. Nothing actually happens, yet a sense of intensity is unmistakably generated. Muehlemann only paints after long contemplation of the empty canvas. Then: 'I must pull out of myself something from nothingness . . . A suspension of everything else but a belief . . .'

catherine murphy

stairwell

1980

oil on canvas

104.1 × 86.4 cm

In 1981 the San Antonio Museum of Art in Texas held an inaugural exhibition entitled *Real, Really Real, Superreal: Directions in Contemporary American Realism*. Although only specifying their own country, the threefold division they provided holds generally good. Catherine Murphy was placed in the central group, the exponents of a realism that was sharply focused yet remained personal, one that preserved a certain freedom but was characterized by 'cool and detached observation'. Murphy's work is certainly in a central tradition, but its very reticence and modesty can cause us to miss the complexities that underlie her 'detached observations'. *Stairwell* is by no means merely 'really real', a snapshot view of a house interior, perhaps her own house in Dutchess County. A critic who perhaps suspected that there was more here than met the casual eye asked her comment on it. She replied: 'I have said all I have to say about the painting in the work itself.' And again: 'I prefer leaving the viewer to his or her own devices.' What these 'devices' amount to is, of course, up to us. Murphy needs only to be 'viewed', though, for subtleties to emerge. Those stalwart china elephants, marching with such bright aplomb in the sunlight, going nowhere but unconcerned, happily regimented and non-animate; and the equally sun-lit birds of paradise, that sit triumphant and nonchalant on their regimented branches: both contrast sharply and painfully with the two human creatures standing in the darkened stairwell. The women, sexed and untidy, diverse and confrontational, blocking each other's way forward, each turning a back to the sunshine, hedged round by the idiosyncrasies of their home furniture: these tensely unregimented creatures are experiencing life as the happy non-animate do not and cannot, and any paradise they know they must seek out for themselves. Murphy says all this, quite simply, just in the light and shade. The stair indeed has a well, and we all know what is proverbially found in wells: the Truth. Slender woman and lumpy woman may not enjoy the truth, but they stand in it and, like Murphy's viewer, are respectfully left to their own devices, to the profound surprises that maturing time may bring.

elizabeth murray

deeper than d

1983

oil on canvas

269 × 259.1 cm

Critics often link Elizabeth Murray with Frank Stella, because of the wild originality with which their works are physically structured: part sculpture and part painting, they are fractured, multi-layered, three-dimensional. But the motive impelling them is very different. Stella has said: 'All I want … is that you can see the whole idea without any confusion.' Murray, though she creates without confusion, intends to draw us deeper and deeper into an 'idea' that she herself can only intuit, and which spirals down in ever increasing subtlety. *Deeper than D* is named for her mother, Dorothy, who was dying, and whom Murray began to realize she could never wholly comprehend. In this sense the work is a symbol of all Murray's pictures: the shapes and images can be interpreted, but the total effect is 'deeper', and beyond the concepts of the rational intellect. Murray told Kathy Halbreich and Sue Graze, who dialogued with her for a year about her art, that her mother's death brought home to her what she wanted her work 'to be around and about … I felt both beauty and sadness: I really wanted to respond to that mix of emotions … to respond to being alive, to learning about death, and how those things mingle'. It is very clear that uniting contradictories is fundamental to all Murray does. *Deeper than D* is on one level very simple, using the household imagery with which she has always worked. We see a spectral blue chair, floating (drawn up, perhaps, by the radiant beam of light that streams from the lit window?), and around it are the walls of a room, all enclosed in Murray's familiar bean–womb–head shapes. But the seat of the chair is also an easel, stabbed by a brush, and also a simplified face, stabbed by light. And the other forms, the two heads, reveal themselves as clinging together with a moving tenderness. They embrace, and in so doing they contain within themselves the multicoloured room and its contents. Murray warns that what is left out is as vital as what is contained, and the two central gaps cry out to be given meaning. Are they expressions of hollowness, of our human yearnings, of the inevitable fallings-short of even the closest relationships, or are they visual cries of pain, like the screaming mouth in Munch, which Murray has used in another work? Whatever the 'meaning', we have 'a knitting of oppositions'; that co-existence is where the satisfaction resides.

christa näher

brücke

1987

oil on canvas

90 × 50 cm

It is seductive, though perhaps not sensible, to see national characteristics in art. It is especially seductive in German art, when from Altdorfer and Dürer to our contemporary Kiefer we find a quality of romantic profundity, a sort of moral weight, a grieving grandeur, that is uniquely German. Even if there are as many exceptions as examples of this quality, it is surely precisely this that gives Christa Näher her imaginative power. Her work has a beauty that is far more than a surface beauty, an appeal that it is very difficult to verbalize. Näher herself has written stories and mythologies, and in one of these, *Der Narrenturm* (*The Tower of Madness*), she describes finding a strange building in a strange city; she comes to it with a deep sense of familiarity and personhood, 'wie vor einem alten Bekannten' (as though before someone known for a long time already). The encounter with what is simultaneously known from within and yet never seen before is the closest we can come in symbol to the effect Näher produces visually in her art. *Brücke* is not the first picture she has painted with this title: it is not 'a bridge' or even 'the bridge' that interests Näher, but the idea of bridging, its archetypal significance for us. Her *Brücke*, as here, arises from darkness and flows into darkness. It tells us nothing of the mysterious hinterlands on either side, only that there is a bridge, high above the obscurities of earth. A pale light glimmers in the skies, reflecting in the immensities over which the bridge leaps. Is it a river down below, flooding gently and remorselessly onward? Or is this an urban bridge, and is the central gleam of misty light a streetlamp amidst the canyons and lonelinesses of the modern city? The ambiguity is intentional, drawing our attention to a deeper ambiguity: does such a bridge, forming itself so quietly from the insubstantialities of the natural world, really exist? We all long for a bridging, we all need the hope that what is disparate within us can become part of a whole. It is this internal bridge, known and yet unknown, present more in hope than in actuality, that Näher paints.

alice neel

mother and child (nancy and olivia)

1967

oil on canvas

99.7 × 91.4 cm

Strictly speaking, Alice Neel is not 'contemporary', since she died in 1984. Yet few artist are more profoundly of our times, not just fortuitously, through a chronological coincidence, but deliberately and essentially. As a portrait painter, Neel described herself as 'a collector of souls', but it was the specific soul, the individual formed precisely by 'today' that fascinated her. Commenting on Cézanne's saying that he loved to paint people who had 'grown old naturally in the country', Neel's claim was: 'I love to paint people torn by all the things that they are torn by today in the rat-race in New York'. She wanted to 'show a soul out in the world doing things.' Many of these 'souls' were friends and members of her immediate family. In a long and painful life ('All experience is great providing you live through it!') her points of personal reference were her art and her two children. The 'Mother and Child', here are her daughter-in-law Nancy and her child, Olivia, with the young woman's fear and uncertainty about her first child made touchingly plain. Nancy seems very alone, very taut and intense as she accepts her responsibility to the struggling baby and confronts a hazardous future with open-eyed dignity. Neel shows us, uncompromisingly, one particular young mother, but Nancy is at the same time all young mothers, all contemporary women who know what they do not want, but . . . must be free and live and discover what they want . . . the slave can only dream of what he will have after freedom . . .' Neel refused to pose her sitters, to 'deliberate and then concoct'. What she sought above all was 'spontaneity and concentration on that person to come across'. There is an almost eerie sense of detachment from self, as Neel lost herself 'in' the other. 'I have no self – I've gone into this other person.' It is almost as if Neel actually needed the other: 'my way to overcome the alienation . . . my ticket to reality'. She therefore paints the other, and herself, too: all her work, however true to the sitter's character, is also a self-portrait and a portrait of our times. 'I tried to reflect innocently the twentieth century and my feelings and perceptions . . . as a woman.' Neel, in her particularity, is a transcendent artist.

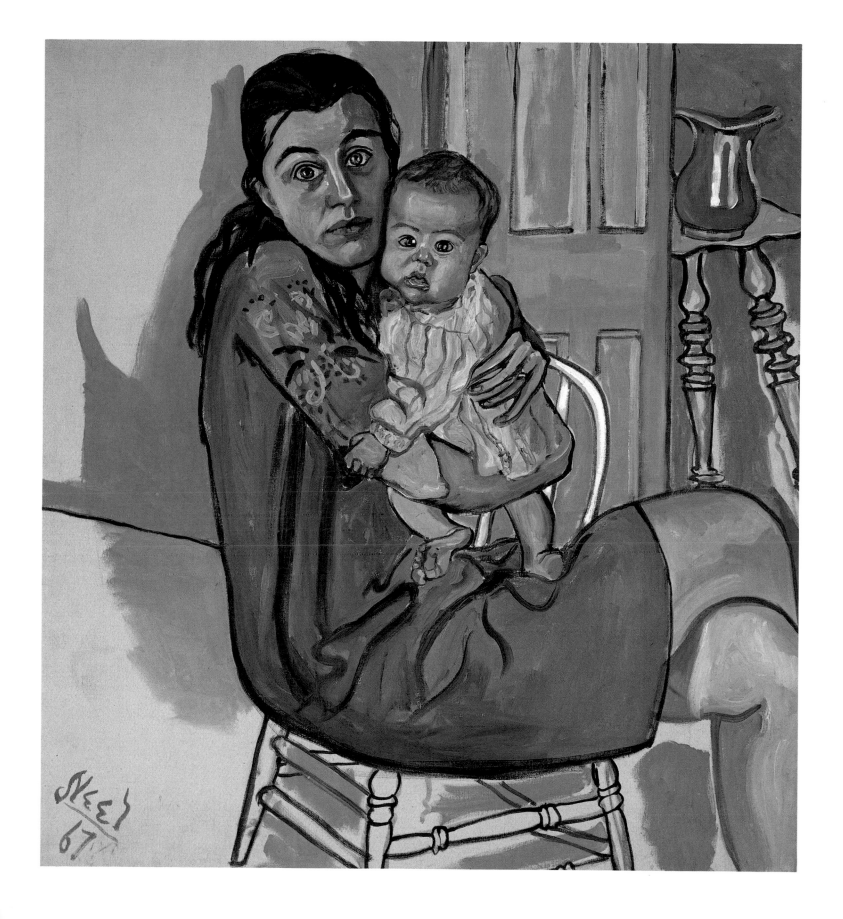

joan nelson

untitled (357)
1985
pigment and wax on wood
40.6 × 46.4 cm

Included in a group exhibition, such as the Guggenheim's *New Horizons*, Joan Nelson's work can be overlooked: small, austere, unassertive, it reserves its secrets for those who really want to see them. But for those who do bring to them a seeing eye, her paintings have an extraordinary beauty. Nelson uses a rather unusual material, mixing her pigments with wax, and building up an almost three-dimensional quality. Paradoxically, she needs this materiality so as to anchor the spirituality that is her paintings' most powerful impress. *Untitled* (1985) is, typically, a landscape and one that has known a sophisticated human presence. We are looking at a buttressed wall, perhaps a sea wall, that moves inexorably into the far distance, dividing earth or water from the pale and passive sky. Delighting like any minimalist in geometry, Nelson sets her perpendiculars and right-angles in their solitary patternings, with the buttress angles re-echoed both as shadow and reflection. Yet the subject of the picture is not the wall, not its appearance as such, but rather its mysterious loneliness. We see what is there, yet seem to be denied any understanding of its nature. Not only are there no inhabitants of the landscape, but it seems essential that there never can be. Loneliness that yet stands four square against the elements is innate to Nelson's vision. Her painting has been called apocalyptic, with critics uncertain whether she is showing us an end or a potential beginning. Have all who built or have known the wall gone for ever? Or are we in the position of the Anglo-Saxon poets, marvelling at the works of the Giants, the remains of Roman architecture? Nelson's recorded statement seems to come down on the side of an end: 'There are human-constructured places which exist seemingly without habitation by living things ... The attractive/repulsive quality of these areas beckons my memory to visit them again and again ... I feel that they are universal, part of a collective memory.' But if *Untitled* arises from 'collective memory', then it surely speaks of a beginning, an apocalypse overcome? We note that the horizon line here is not a flat horizontal. It rises gently upwards as our eye moves across the image. The waxen colours, delicate and pure, glow with an interior light that makes them poignantly evocative, not of loss, but of loss and pain transfigured. Their subtly modulating tones of hope are far more expressive and moving than any forthright statement. Nelson invites us into the silent depth of an unknown – unknowable – but essentially beautiful world. Her deepest note is hope.

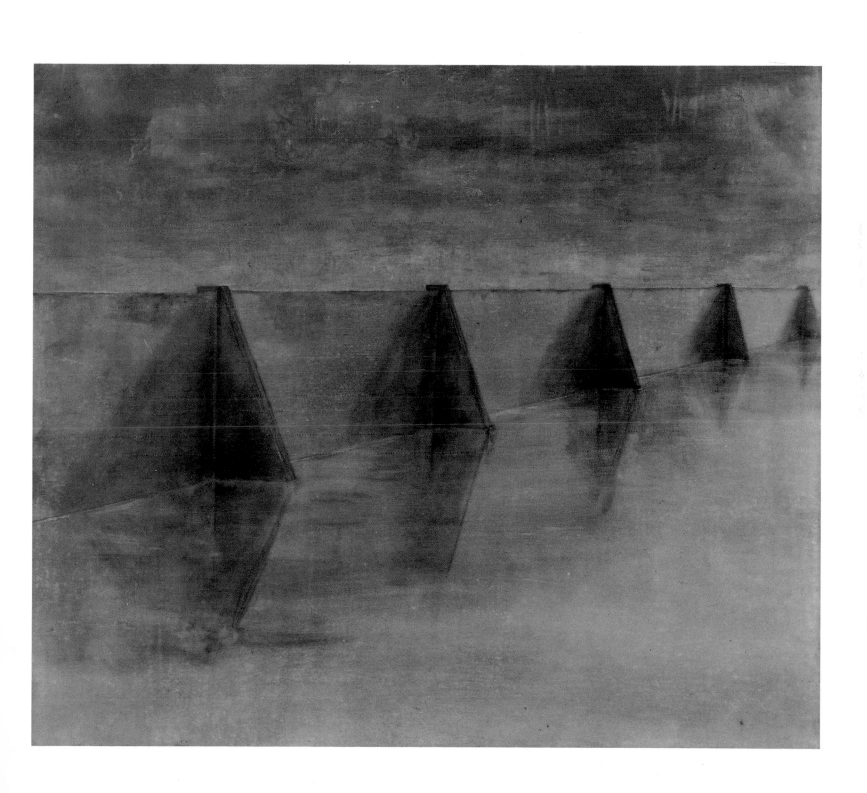

thérèse oulton

spinner

1986

oil on canvas

234 × 213.5 cm

Unconsciously, what we naturally long to do with an art work is to consume it. We want to recognize what it 'depicts', take possession of it, and thus defang any threat of the unknown. The problem of the abstract artist is to keep the viewer from playing games with the work, 'reading into it', and yet hold the gaze sufficiently long for the art to be able to begin its magic. Thérèse Oulton's work was at first triumphantly 'consumed'. Admiring viewers hailed it as Turneresque and gladly insisted on reading her cascades of colour as expressionist landscape. But its hold on material reality is more intellectual than physical. Oulton does not create landscapes as such – or, if they are landscapes, they are of a primarily metaphysical realm. *Spinner* forms part of a series of paintings with the collective title *Letters to Rose*. Rose is, perhaps, any woman, woman as seen by the male, who trivializes her as a flower or makes her a colour in the world's life and not a functioning equal. Again, 'Rose', as Duchamp once indicated, is an anagram for 'Eros', and Oulton's work has a strong but non-specific erotic power. *Spinner* suggests in its title both woman at her age-old toil and also the spider, uncanny workmate. The gleaming and tremulous coil that falls diagonally across the canvas has appeared in other works by her, most notably in *Mortal Coil* and *The Heart of the Matter*, weighty titles that are here recalled in silence. The curving parallels to the left are also quotations from earlier paintings, such as *The Passions No. 6*, or *Cast* in the Letters series, with its suggestion of animal ribs. Are they ribs? Stair-rungs? Balconies? They are none of these things. Oulton dwells lovingly on the theme of transubstantiation, the alchemist's certainty that all matter, however brute, is potentially spirit. She seems to place herself so deeply within this tradition that we are drawn into it with her. The almost infinite diversity of her colour and its threadlike nature (spun by a spinner of the spirit), refuses the predictability of any one interpretation. Oulton has humorously referred to pure representation as 'male thuggery'. As delicately ambivalent as a rose, as passionately powerful as an Eros, she leaves each one of us to be our own Spinner.

ann page

seal

1982

mixed media construction

190.5 × 190.5 × 7.62 cm

A work of art on paper is an insistent parable: 'treasure in earthen vessels', something precious that bears the stigma of its mortality. Ann Page, herself the child of both eastern and western traditions, carries the parable a stage further by working with paper as her essential medium. Using a long-fibred paper that is akin to the Japanese handmade papers, she creates a substance that maintains its frailty while accomplishing a presence of immense power. She dyes the paper so that, in receiving its hue, it receives also the wounds of its nature: the paper shrinks, shrivels, warps. For Page, this wrinkling is not an obstacle to be overcome but a vital part of the creative process. We could say that *Seal*, like all her work, is a visual expression of age and time's ravages, accepted and seen as beautiful. Like all her work, too, it is as much a sculpture as a painting. It droops from the wall, and the shadow is part of its substance – another visual parable. Page fashioned it from four triangular wedges of paper, intending the geometric shape to carry an emblematic meaning. Both the inner cross – the X-form – and the outer square are tantric symbols, as is the hesitant blood-red circle that inscribes itself upon the golden background. We are not meant, I think, to tie these symbols down to specifics; they are traditional in all cultures, and all speak to us in some degree of wholeness. Poignantly, the circle is not physically a whole; its ends reach out to each other, as if seeking a completeness that earth cannot provide. The red, also, has a moving vulnerability. Page uses colours for more than their visual effect. White, in her work, symbolizes woman, and black, man. The golden brightness of *Seal* is edged with a ragged black, and it casts a black shadow, significantly, on a white wall. In each of her works there is a touch, at least, of red: the blood colour, the colour 'of iron earth, of flesh and flowers, vital red, gravid red'. This suggests to us what *Seal* is actually 'sealing': not a casual pact, but one signed with the heart's blood, a 'seal' between God and humanity, woman and man, life and death, truth and illusion. *Seal* is a ritual object, at once humble and magnificent. It asks to be approached with reverence.

katherine porter

stars hide your fires

1986

oil on linen

204.5 × 188 cm

Macbeth tells the stars to 'hide your fires' at a moment of deep ambivalence; he longs for power, he shrinks from the moral cost of it. Hence the shame that desires darkness: 'Let not light see my black and deep desires.' It is with this state of violence, of self-hate, of evil chosen yet detested, that much of Katherine Porter's work is concerned. She is a deeply moral painter, and we diminish her if we see these anxieties as primarily political. She clearly has political concerns: nuclear war and the small tyrannical wars of big nations against small – these themes frequently shape her imagery and provide its tone of anguish. But we feel in Porter than her anxieties are matters of principle. She grieves over and warns against destructive elements within the human heart. We are all tyrants, all despoilers, all creators of holocaust in our own self-seeking. *Stars Hide Your Fires* shows a world in chaos, with tornado storms twisting down upon it from every side. It is a world become 'unnatural', where the billowing flames are a chemical blue and where the setting has an incomprehensible pattern of multi-coloured tesserae. Most ominous of all, however, is the shrinking border. Porter often frames her pictures in a coloured border, as if to contain their violence. Here she starts boldly, with a fairly regular black, white and red. But it peters out, chaos takes over, and when the border reasserts itself, much neater and tighter, it rapidly gives up successive ghosts, one frame yielding to another, until we reach the uncertain centre. At the heart of the picture, symbol of our innermost truth, there quavers a faint sketch, barely legible: is it splintered planks and two flying figures? They alone in the picture are denied the rich soil colours that make Porter's painting such a delight to the eye. Is she warning us that we may end in a heart made empty? If so, her warning comes with hope. Although she knows that 'visions of the apocalypse are symbolic of the darkness within us; the conflict of good and evil, the very physical manifestations of the consequences of evil, and of the terrifying chaos, in nature . . . The possibility of resolution – man with nature is what I believe in . . . our responsibility and a brighter future.'

bridget riley

ra

1980

gouache on paper mounted
on linen

253.4 × 217.8 cm

Like Seurat (a comparison she can withstand), Bridget Riley is a 'scientific' painter. She works to a theory, making many and exact experiments, even using assistants to map out and investigate possibilities for her. This can sound a rigorously conceptual approach, yet the result is work of a unique and startling beauty. Riley says, quite literally, 'what I want' is 'the music of colour'. This is a precise expression. Individual notes are not 'music'. They become music only in certain combinations, and it is that union and interdependence that creates a composition out of initially random sound. So, Riley argues, each colour has to be combined with another, in different proportions and various positions so as to release its potential, to free it into its possible beauty. Each colour is to be freed, and each must free its neighbours: painting for Riley can be seen as a work of communion, a practical act of love. *Ra* is one of the series Riley painted after a significant visit to Egypt at the start of the eighties. It was an overwhelming experience of colour, especially the five colours of the Egyptian landscape – red, yellow, blue, turquoise and green, plus the black and white that Riley had used almost exhaustively already. These colours were found in all their freshness in the artefacts and art of long buried tomb buildings, and Riley was inspired to use them for columnar pictures which would draw the viewer into the mysterious dazzle that is her chosen medium. There is a sense in which we cannot contemplate a Riley: *Ra* will not stay motionless for us to possess it, any more than will the light. Riley has explained that she does not 'paint light'. Rather, she says, 'I present a colour situation which releases light as you look at it.' She seeks to share with us her own 'dialogue', that of a silent listening, rather like that of one at prayer. As one looks, she says, 'one sees a luminous disembodied light, variously coloured'. *Ra*, like all that 'is', Riley regards as an agent 'of a greater reality, of the bridge which sight throws from our innermost heart to the furthest extension of that which surrounds us. The painting cannot be questioned, probed or stared at' but, 'for those with open eyes', it serenely communicates.

dorothea rockburne

exstasie

1984

oil on canvas

206.5 × 193 × 10 cm

Dorothea Rockburne, in using an archaic spelling for *Exstasie*, recalls John Donne's poem of the same name, and the passionate intellectuality of the Metaphysical poets is the nearest counterpart one can find to her work. Although she insists that she is not interested in mathematics as such, Rockburne is fascinated by the concept of the 'Golden Section'. To the late medieval artist there was a certain division or 'section' one could make in a line that divided it into two parts, one being to the other as the other was to the sum of the two, and this they considered 'golden': the perfect division. It is found in classical art and, what fascinates Rockburne, seems to be endemic in nature. Pine-cones, fern fronds, sea-shells, all form themselves into 'Golden Section' patterns. This seems to her to be magical, a sign of some deep mystical harmony in creation, and in her art she consciously strives, as did her beloved Sienese and Florentine painters, to use this harmony as an instrument. In study after study Rockburne works out the structure of her proportions. Then, she says, 'I look at the shapes until I see them in colour.' This long, painstaking preliminary work is fundamental, because Rockburne needs to be absolutely free when she finally comes to create the painting. *Exstasie* is more than the title of the finished work, it is a hesitant confession of the manner in which the artist was privileged to fashion it. The overpowering presence of her art, its mystical weight, comes from this intensely un-selfed working method. Rockburne, whose emotions run too deep to be lightly verbalized, has said: 'I thoroughly want the experience of this paint, this structure, this feeling, to be known to me before I make this painting. Then when I begin again so much is known to me that I can "stand outside myself" and enter into a state of ecstasy'. Ecstasy earned, as it were, sweated for, paid for at the cost of a total dedication, of an absolute of concentration and surrender of the narrowness of the ego: if one is ready to pay the price, one can receive for oneself what *Exstasie* is. One cannot (one dare not) 'comment' on it, but one may prayerfully aspire to understand it from within.

susan rothenberg

a golden moment

1985

oil on canvas

137.2 × 121 cm

When Susan Rothenberg came into prominence in the mid-seventies she was using the horse as her motif, and she did so for several years. It was not, she explained, that she was especially interested in the horse, as such, but having a settled theme set her free 'to do everything you could to the horse image, by tying in to geometry and putting it through the paces.' This interest in geometry as a tool has persisted, and may underlie her four recent pictures of Mondrian, the great Dutch abstractionist, of which *A Golden Moment* is one. Rothenberg has realized that her horse-images were basically self-portraits. (The two iconic horses that represented her in the Berlin Zeitgeist Exhibition of 1982 can certainly be seen as profoundly personal.) In depicting Mondrian, too, that austere and rigorous master of the square, there is also an element of self-revelation. Although it is unmistakably Mondrian himself who here smiles out at us, thin, tall, bespectacled, it is her own emotion Rothenberg shows us. When Mondrian escaped to America during the war, his reverential hosts were amazed to find him so simple, so unaffectedly delighted with the exuberance of his new homeland. Here Rothenberg catches him at the 'moment of emotion' that she herself knows so intimately, the golden pleasure of artistic rightness. Before him are spread suggestions of the primary colour squares with which most of his work is concerned, but it is not the physical squares so much as the thought of them, the love of them, that renders the artist beatific. The work has a golden core, light enveloping Mondrian's hand and paint-brush. The mysterious whiteness of the canvas gleams seductively before him, as her own canvas must gleam before Rothenberg. A light that is luminous and feathery, disembodying all forms while simultaneously flickering them into a sort of rapturous beauty, is specific to Rothenberg, not Mondrian, yet she is somehow making clear to us that for him, as for her, painting is not a rational act: 'work is not run through a rational part of my brain. It comes from a place in me that I don't choose to examine'. The golden moment is pure gift, she suggests. It 'comes', and the artist can only sit back smilingly and allow it to be present. Yet Mondrian's gaunt frame indicates the conditions if we are to experience the vision for ourselves.

sandra mendelsohn rubin

self-portrait

1986

oil on canvas

61 × 37.5 cm

The National Portrait Gallery called its recent exhibition of photographic self-portraits 'Staging the Self', a title which neatly catches both aspects of this genre: revelation (the self) and concealment (staging). A few artists, for example Rembrandt, can turn even the staging into a more true and honest confrontation with the essential self. This has been especially true of women artists, who in the past have had to present an image of themselves that would not alienate the patriarchal male. Even for the contemporary woman artist, there has to be a deliberate choice of objectivity, and this is the most striking element in Sandra Mendelsohn Rubin's *Self-portrait*. It is wholly uningratiating, amazingly free of self-interest or natural vanity. Her one concern seems to be the light, the visual truth of what she sees before her. Rubin has said that at the heart of her work there is a 'response to something living, changing and tangibly present'. Her context is her landscape paintings, as she continues: 'Although the paintings are very specific in place and time, they are really an orchestration of many observations, formed and reformed . . . they emerge from an external as well as an internal understanding.' She has evidently brought off here the great feat of regarding her own face and person as if it were a landscape, and the immediate effect is startling. Externally, we see a cold Californian light bathe a solitary woman standing in a low basement. A preparatory drawing for this work makes it clear that there is a washing-machine to one side, a telephone to the other; her drawings hang behind her, and beyond them stand art books (including the Metropolitan Museum catalogue of Van Gogh in Arles) and a calendar. Rubin is depicted in the actual context of her life, with all its concerns, domestic, professional, educational, temporal and emotional – the last indicated by the portrait closest to her own head. But what gives the scene its pure dignity, its great and subtle beauty, is the 'internal understanding'. It is light that the painter loves, not the body that it illuminates; yet it is her body, too, and she manifests a serene confidence in its bare humanity. *Self-portrait* is a rare image of self-respect, and is its own justification.

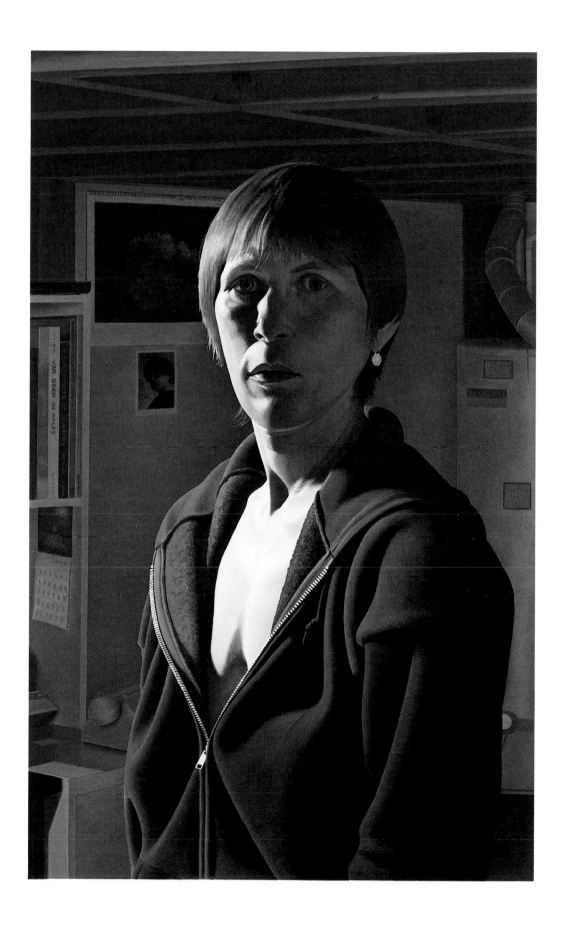

claire seidl

the eye of the realist is inflatable

1986

oil on canvas

129.5 × 213.4 cm

From the long list of thematic exhibitions with which Claire Seidl has been concerned we could pick out fairly apt descriptions of how this young woman paints. Her free, uninhibited intensities are well suggested by, for example, 'Passionate Abstraction', 'Art Implosionism', 'Current Memories: Painters who use their Dreams', or 'Nature Transformed'. Seidl does all these things: abstracts with a carefree passion, implodes realism into artistic freedom, makes her memories 'current', and transforms nature with the confidence of an intelligently perceptive eye. *The Eye of the Realist is Inflatable* is a high-spirited celebration of all this potential. The real 'Realist', Seidl assures us, is the abstract artist, an implicit assertion that recalls Pat Steir's conviction that the more closely we look at nature the less clearly and divisively we see. When one's eyes are wide open to the infinitesimal detail, then we 'see' only abstraction. Seidl 'inflates' her eye, widens it beyond rationality, and a splendour of line and colour appears before us. One reading of the picture could see a massive head in the moonlike centre, with an eye inflating in all directions, but any attempt to be literal would destroy the work's happy abandon. It is only an apparent abandon, of course, one of mood. In actuality, the drawing is powerfully controlled, with the swinging black lines weaving out and round, uniting all the scattered sweetnesses of colour into a superbly orchestrated whole. We are made aware of geometry and, simultaneously, of nature the catalyst, bursting into change and exploding us with her. If Seidl is not solemn, she is absolute in her seriousness. We are not being asked to rejoice without cause. Here is clearly a painter who is unafraid of time's velocity, who can tackle the unknown and the unexpected, who sees no reason to protect herself with caution or with mollifying gestures. She can afford to be both realist and visually inflatable, because at base she trusts what she is and what she sees. Not all artists, young or old, have this confidence, but its innocence and sincerity make Seidl a delight for eye and heart.

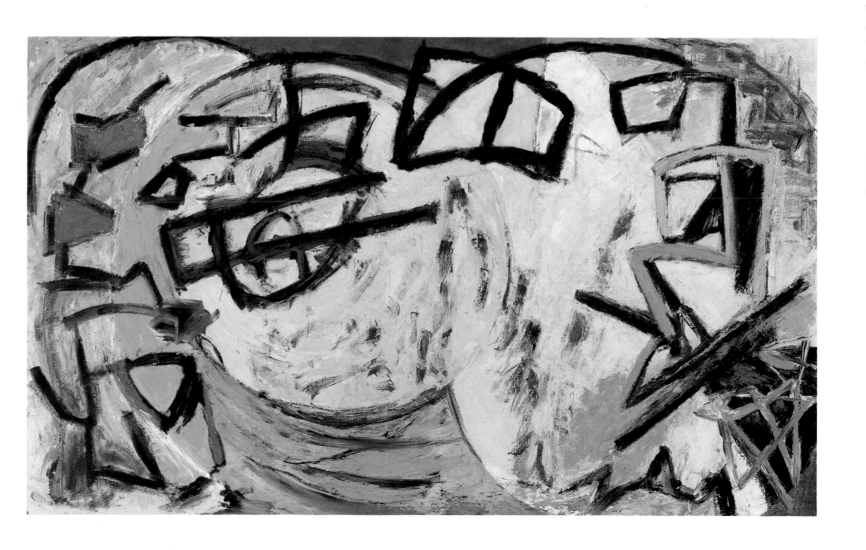

cindy sherman

untitled #122

1983

Photograph

Some fortunate artists discover that a deep personal interest can be made into a life's work as art. Cindy Sherman is of this company, an artist who raises a private preoccupation to the level of pure art, and in so doing, raises us with her. It is also an accessible and general preoccupation, one that elicits an immediate and fascinated response from nearly everyone. This is important to Sherman. 'I like the idea that people who don't know anything about art can look at [my art] and appreciate it . . .' But it is in fact easier to appreciate it than to explain what exactly it is that Sherman does. Essentially, of course, she takes photographs of herself, but we must at once qualify this by saying that she is not herself the photographer in any artistic sense. She has declared a lack of interest in photography as such and sends her negatives away to be processed. Furthermore, it is not strictly 'herself' that Sherman photographs. This radical absence of ego-involvement is one of the main contributions to the resultant appeal of the images. They have an objectivity and innocence that allows us to indulge our curiosity without either prying or taking illicit part in a narcissistic orgy. Sherman is acting, acting so passionately that 'she' herself is no longer there, no obstacle to our entering into the emotions and the situations of someone else. *Untitled #122* is both comic, pitiable and frightening. The blonde is so furiously angry, so helpless, so unaware of anything except her own condition. Sherman prepares for each image without too definite a picture of what will come forth. As she stages her scene, arranging props, clothes, make-up, pondering stance and lighting, the image forms itself. She has said that she enjoys 'the control of being the director as well as the actor', and control is certainly fundamental to her art. Perhaps the most fruitful way to approach it is as Performance Art, that powerful medium which can sweep us from our moorings when experienced but which cannot be maintained, as other less direct forms of art can be. There is immense dignity in this self exposure, which is very touching: Sherman trusts us to respect what she shows, and to know that it is not 'her'. She provides the image, we must give it meaning.

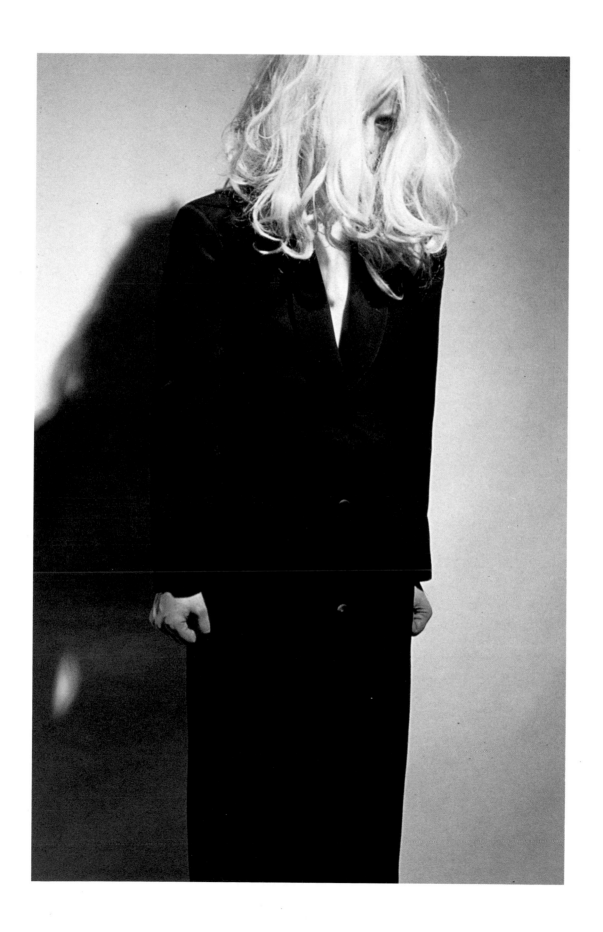

linda sokolowski

binghamton beyond jefferson
1985
mixed media and collage
116.6 × 111.8 cm

Linda Sokolowski lives in Binghamton (she is an Associate Professor of Art at Harpur College there), so presumably this exactly worded title refers to an actual local site. If we went 'beyond Jefferson', this is apparently what we would see. Sokolowski has made no attempt to dramatize the scene; she leaves the buildings in their unromantic mortarized roughness; the waters flow and seep over stepping-stones that are materially and simply displayed across the surface. Yet, for some mysterious reason, all seems bathed in an unearthly softness. This both is and is not the local landscape. It is not a version of the poet's 'land of lost content' ('The happy country where I went/And may not come again') because the 'content' is not 'lost', merely one stage removed from us. A sort of translucent veil seems invisibly to overlay the scene before us. The hut-houses – sheds? barns? – do not have practical roofing, but a coloured wash of patches floats across them. The distant hills and the sunlit trees have that hazy brightness that sometimes presages a storm, while the sky is a dense stillness of faintly pink-and-mauve cloud cluster. All the colours are both too bright and too remote. Nevertheless, Sokolowski has angled through her composition one diagonal leading into another, carrying us from the lower left corner in elegant zigzags until we are safely guided to the highest trees on the right, with only that shimmering sky above. We have here an interplay of reality and imagination; the actual has become more of an interior and emotional truth, not in spite of but because of the realistic elements with which the artist works. Sokolowski appears to be implying that all nature, however unexciting, is potentially a means of liberation. We need not go in search for our 'content', not mourn it as irretrievably 'lost' to us. If we have eyes to see, we can see. It is the intensity of love and not the material lineaments that make *Binghamton Beyond Jefferson* so restful, so evocative of spiritual goodness, so profoundly tranquillizing a scene.

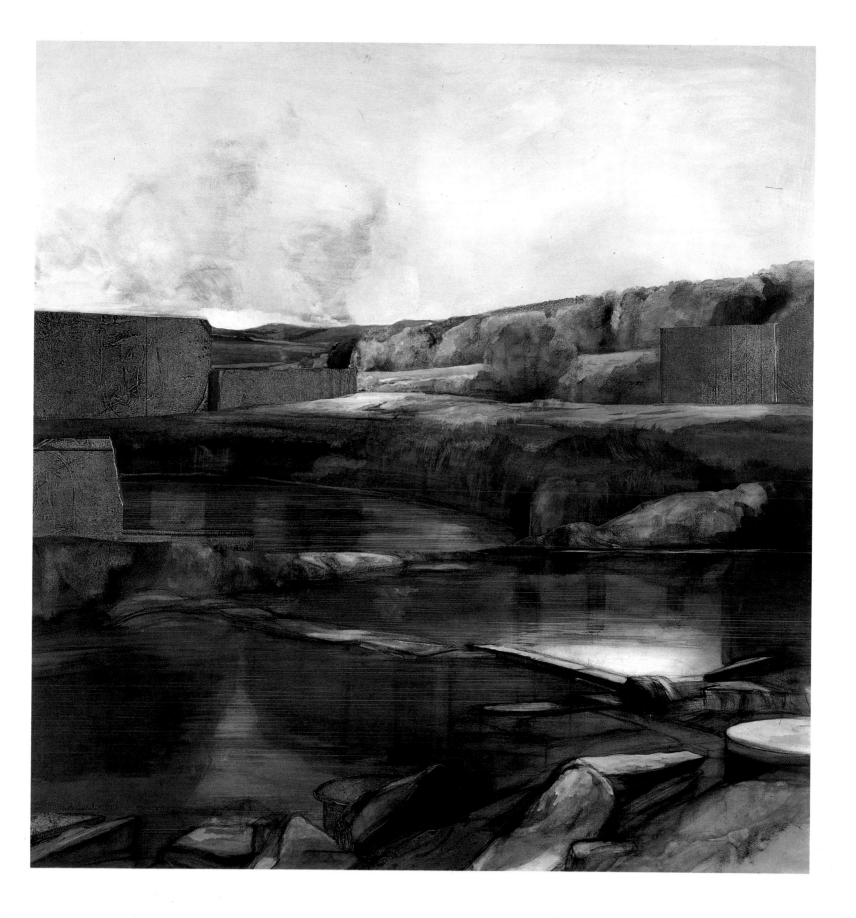

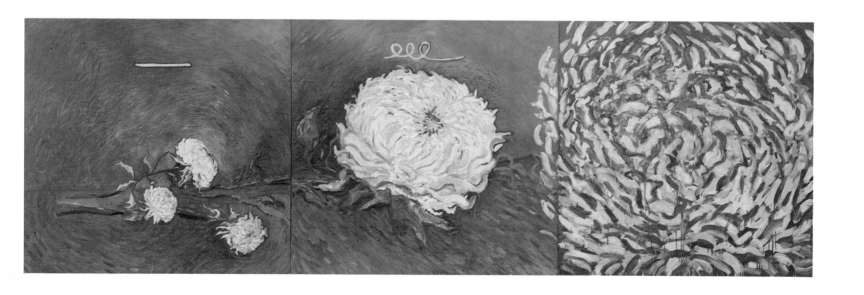

pia stern

dream of a departing mentor

1985

oil on canvas

167.6 × 137.2 cm

Thomas Albright, in *Art in the San Francisco Bay Area*, has a section on 'personal mythologies and private dreams'. But when art is personal and private, we can feel an irritating sense of exclusion. The artist has therefore to win our trust and lure us into his 'private dreams' in a way that we can understand. Pia Stern, though too young an artist to feature in Albright's history, has an unusual power of transforming her 'dreams' into our own. They remain hers; she does not share them. For instance, we have no idea who the 'mentor' is and why there is a 'departure'. But we are not asked to riddle out Stern's private meanings. The 'Dream' has an objective existence. If, as critics have suggested, the frequent appearance in her work of a rudimentary house, lit from within but fenced off from the onlooker, and of ladders, paths, and symbols of leave-taking, is a family 'memory' of the childhood escape of both her parents from Nazi Germany, then this is not of its essence. All life knows longings, departures; all hearts yearn for that security we picture within the child's simple house. Stern is not dwelling on her own emotions but on ours or, rather, on her own as they express what happens within our own dreams, too. The artist seeks out the great secrets of the heart and bodies them forth. 'I have always thought of artists', says Stern, 'as "truth-seekers" of some sort.' She defines this truth as beyond that of 'the ego that demands', and says the artist seeks above all 'simply to be'. It is a wholly contemplative understanding of the artist's vision, both unearthly and very present in its beauty. In *Dream of a Departing Mentor*, the lighted window is in itself a 'house', a security, where the Mentor, too large to be confined to our miniature world, gazes benignly and obliquely out. Mysterious written scrawls surround the rough outlines of the head: language that only the Mentor understands, perhaps. The window suggests a train, with the departing one looking out, and it may be a railway-line, as well as a ladder, that is hinted at on the left. Amidst the otherworldly brightness of the colours, lies a radiant heart, not so much exposed as surrendered, pliant to life's wisdom. In a sense, the Mentor 'remains' because art, making Dream into Truth, keeps all Departure eternally in process.

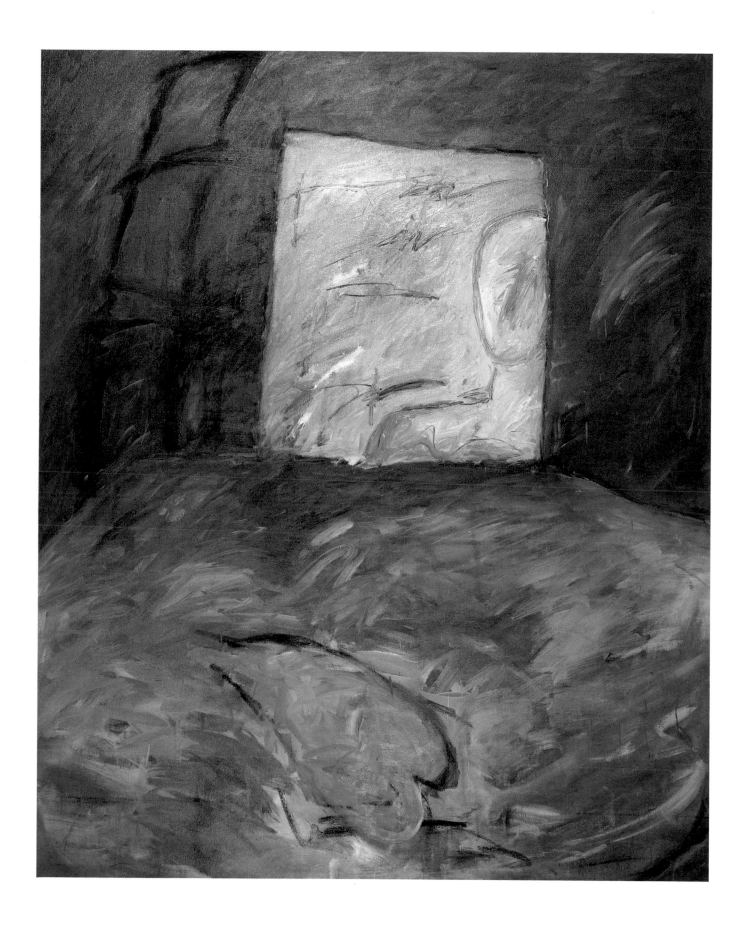

michelle stuart

nazca lines star chart

1981–2

earth from site in Nazca
Plateau, Peru. Rag paper
mounted on rag board

300 × 420 cm

When the University of Colorado showed Michelle Stuart's *Voyages*, a semi-installation exhibition, the journalist Jennifer Heath compared entering the gallery to 'a squeezing into a cave, but once inside, a heartbreaking vastness takes over. These dream-like, precise, architectural works are each rituals, describing without nostalgia, but with affection for the earth's body, the layered evolution of the planet.' For those who cannot actually know the physical impact of Stuart's work, that description is as good as we can get. Stuart has always worked directly with the matter of the earth, reverencing it, feeling its weight of forgotten history, loving it for its beauty and its dignity. She has worked as a cartographer, and, even as a child, explored the wilderness with her father, a waterfield engineer, all of which has made her love for the earth as educated as it is instinctive. Stuart has made hauntingly beautiful installations, she has raised earth art in lovely and primitive places, she has painted with vegetation incorporated into the canvas, she has made mysterious earth 'books', wordless, sealed with feathers or grass, books to be read without opening. *Nazca Lines Star Chart* perhaps combines her magical insights and techniques. It is 'painted' with the actual soil of the Nazca plateau in Peru. On the thin cardboard of tiles, Stuart has patiently rubbed in the coloured earth, her slow, intense pressure in itself a symbol. (Lawrence Alloway remembers visiting the loft which Stuart shared with other artists, and hearing a continual thudding noise: Michelle 'drawing', he was told.) The long-dead Indians of Peru made great shallow cuts in the earth, purposeful and beautiful patterns that no one now can understand. Stuart believes they were 'Star Charts', and over her grid of tiles, ironic homage to the intellectual framework with which we make our world controllable, she has traced the strong, straight diagonals of these extinct people. The patterning and the faintly luminous earth grounds are not only beautiful, they have that tactile weightiness that Stuart feels we need to relearn. We are to 'catch something that's uncatchable, to catch the essence of history ... fear and awe and drama ... a potential for magic'.

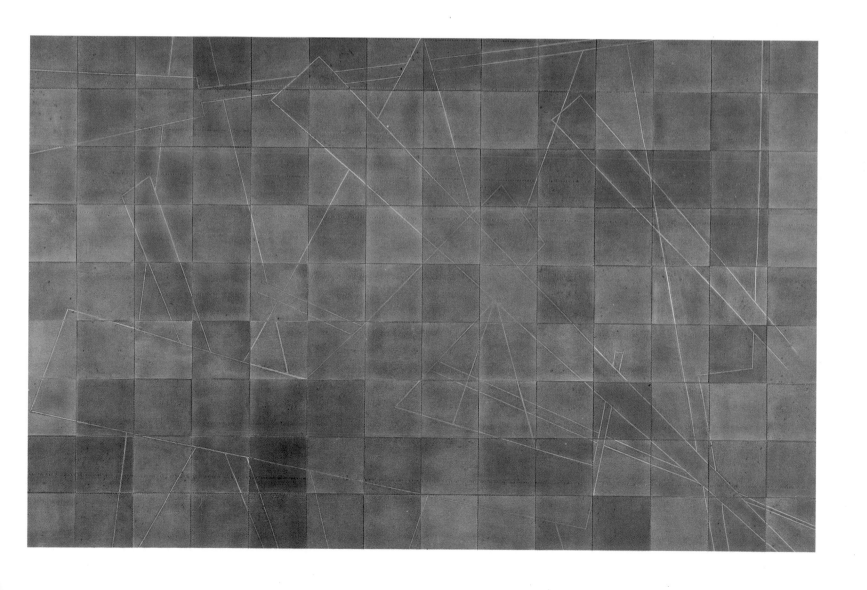

kate whiteford

lustra

1984

oil and gold pigment on
canvas

200 × 300 cm

In the 1987 John Moore's Exhibition in Liverpool, Kate Whiteford was a major prizewinner. This speaks well for the insight of the judges, because her work does not show to advantage in a public gallery. She is really an installation artist, and what she is offering can only be truly seen within the shrine-like precincts of a place for worship. *Concerning the Spiral*, the work that was awarded the prize, is very like *Lustra*, in that both – like all Whiteford does – deal with 'signs and symbols', which she sees as 'providing a pivotal point of belief, of contemplation'. Whiteford is not trying to pretend that, for us, these signs still have their primitive magic. We live by a different rhythm, and we do not come to art primarily to see our beliefs made visible. Art as entertainment, art as pleasure: Whiteford denies none of this. She merely indicates, with the gentlest of gestures, that we should not circumscribe our possibilities. If man in the past could use his art to enter into his heart and there meet his gods, does it mean that for us the door is for ever barred? Doors occur frequently in Whiteford's work, 'rites of passage' in a literal sense. In fact, a stay in Nepal revealed to her that the people there still used their simple shrines as entrances into prayer. What the shrines contained was often faded and, in itself, unimpressive, but it bore the 'lustre' of the urgencies of faith. Whiteford shows us images rubbed almost bare by the age-old clasp of a praying hand. Her gold and scarlet fish are emblems we do not need deciphered. *Lustra* carries many connotations: we hear the echoes of priestly lustrations; and the glimmer of light – underwater? crepuscular? – shows us a mysterious il-lustration, with its ritual mask, its hinted maze, its faded refusal to speak plainly in our own tongue. Are we gazing at a wall? a priestly vessel? We are not meant to 'know', but to be silenced, to be made to wonder. Whiteford has used gold pigment with her oils, to impress upon our materialist noisiness that the true place for gold is in the temple. Contemplating her silent symbols, we can let their presence lustrate our hearts, and illustrate what she calls 'archetypal images of spiritual worship'.

alison wilding

nature: blue and gold

1984

Brass, ash, oil, pigment

47 × 109 × 22 cm

Alison Wilding has said: 'The obverse of making is looking, not telling', and her work, so simple in its poetic dignity, resists the intrusion of any 'explanation'. She implicitly demands that we look at it for ourselves and accept its symbolism as untranslatable: symbol of its own reality. Wilding says that she has singled out, as 'the rationale central to hopes for my sculpture', that 'whilst firmly placed in our world, the sculpture should take us out of it, offering a glimpse of an alternative order.' Wilding wants to show us 'Nature', but simultaneously to make us see that it is 'Blue and Gold'. The work is immensely self-contained. Many of her small and perfect sculptures are in two parts, one providing a palisade, a monastic enclosure, for the other. *Nature: Blue and Gold* does not need this encirclement. There are two parts, indeed, but they are united in mutual embrace. Each is wholly distinct from the other. The kernel, a deep absorbent blue, is carved from ash wood; it is simple, passive, alluringly tactile and rounded. The wings of brass that clasp it are a glitter of decorated gold, sharp and dualistic, cold, hard, alluring only to the eye. Yet they are one, and the inevitable comparison of a marriage comes to mind. (It would belittle the poetry to turn the symbol into an allegory.) Within every heart is the same duality, the same yearnings in two opposing directions, the same contradictions that life sets us the task of melding into supportive difference. Which supports which here? A critic has 'read' the Blue as thrusting savagely into the Gold, while it has only seemed to me that the Gold protects its Blue companion, and the Blue raises the Gold and enables it to stand. Each shows, in practice, love for the other. Each also provides the other with an essential for its fulfilment. The Gold, perhaps the heavenly element, perhaps the spiritual, perhaps the intellectual (why not all three?) brings to the sculpture its light: without it the Blue (earth, body, senses?) would be in darkness. But the Blue equally offers solidity and strength to its airy companion, and is both pedestal and light-recipient. No point in offering light unless it can be taken: another symbolic gesture. The alternative order is not unrealizable.

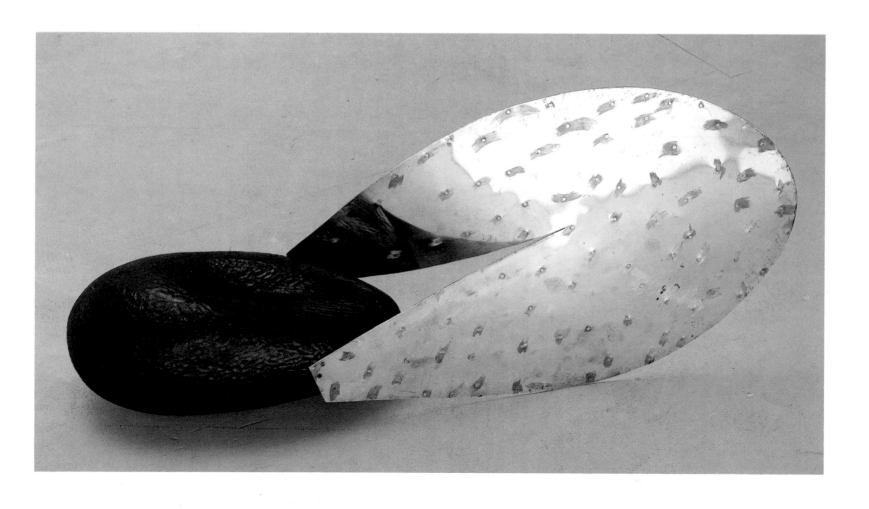

jane wilson

blue carafe

1979–81

oil on canvas

76.2 × 76.2 cm

Admirers of Jane Wilson's landscapes have noticed how free they are, not only of other people, but also of the presence of the artist herself. Wilson effaces her ego-importance so as to perceive and reflect, mirror-like, the full climatic particulars of the scene. Such beautiful reticence is also the secret of her magical power to create a still-life painting such as *Blue Carafe*. Wilson does not need to impose her selfhood because she is too intimately involved with what she paints. It is rather a question of distancing herself sufficiently from it so as to be able to show 'a sudden complete view', as she believes Monet does. Painting does not come easily for her – *Blue Carafe* took over two years to complete, and she describes the process as 'some kind of wrestling match between the known shape and what the person might actually be seeing'. This physical struggle, clearly visible on the canvas, with its countless scrapings and markings, becomes our struggle, too, as we strive to comprehend an apparently straightforward motif. But *Blue Carafe* is elusive in its simplicity, its mystery. What are we looking at? Obviously, there at the back on the right is a luminous blue carafe holding the whole composition together, both centre and climax. But does it stand, together with the milk-jug, etherially gleaming, and the Dürer-like closed pot beside it, on an outspread cascade of exotically patterned cloth? Is that wallpaper behind it, with golden figurines, dancing for joy at life's abundance? Those grapes, like 'great green pearls' (Wilson is her own best commentator), do they spill languidly from another vase onto yet another and more densely textured cloth? We see the apple, half lost in the dim folds of the texture, and, to the right, a bright-eyed fish: all part of the pattern? That Wilson has laboured so long and arduously to hold all this in precarious balance contributes to its final glory. Her colours have a miraculous richness, since the very scratchings of her instruments, no brush but knife and fingers smearing, rubbing and coaxing beauty into being, all set up painterly vibrations that catch the light and give her work an almost mystical radiance. She herself is so utterly committed that her delight is objectively made visible.

select individual bibliographies

Magdalena Abakanowicz
Backs. 1976–82. Burlap and glue. 80 pieces, 3 sizes: 61 × 50 × 55 cm, 69 × 56 × 66 cm, 72 × 59 × 69 cm. Courtesy of the artist
Born in 1930 in Falenty, Poland
Lives in Warsaw, Poland
Dealer: Galerie Alice Pauli, Lausanne
Bibl: P. Jacob and M. Abakanowicz, *Magdalena Abakanowicz* (Abbeville Press, New York, 1982); *Magdalena Abakanowicz* (Catalogue of the Virginia Museum of Fine Arts, Richmond)

Martha Alf
Four Pears. 1986. Coloured pencil on paper. 35.6 × 43.2 cm. Tortue Gallery, Santa Monica, California
Born in 1938 in Berkeley, California
Lives in San Diego, California
Dealer: Tortue Gallery, Santa Monica, California

Gillian Ayres
A Belt of Straw and Ivy Buds. 1983. Oil on canvas. 310 × 167.6 cm. Knoedler Kasmin Ltd
Born in 1930 in London
Lives in North Wales
Dealer: Knoedler Kasmin Ltd, London
Bibl: Tim Hilton, *Gillian Ayres* (Arts Council Catalogue, 1983/4)

Jennifer Bartlett
The Garden (detail). 1981. Enamel on glass. 93 × 48 cm. Saatchi Collection, London
Born in 1941 in Long Beach, California
Lives in Paris and New York
Dealer: Paula Cooper Gallery, New York
Bibl: John Russell, *In the Garden* (Abrams, New York, 1982); M. Goldwater, R. Smith, C. Tomkins, *Jennifer Bartlett* (Abbeville Press, New York, 1985)

Louise Bourgeois
Stake Woman. c.1970. Pink marble. Height 11.43 cm. Private Collection, New York. ©DACS 1988
Born in 1911 in Paris
Lives in New York
Dealer: Robert Miller Gallery, New York
Bibl: Deborah Wye, *Louise Bourgeois* (Museum of Modern Art, New York, 1982); Robert Storr, *Louise Bourgeois* (Galerie Maeght Lelong, Zurich, 1985)

Joan Brown
Out on a Limb. 1986. Acrylic on canvas. 182.9 × 304.8 cm
Born in 1938 in San Francisco, California
Lives in California
Dealer: Koplin Gallery, Los Angeles
Bibl: Thomas Albright, *Art in the San Francisco Bay Area* (University of California Press, 1985)

Elizabeth Butterworth
Yellow-billed Amazon Parrot. 1980. Gouache on canvas. 29 × 24 cm
Born in 1949 in Rochdale, Lancashire
Lives in London
Dealer: Coe Kerr Gallery, New York
Bibl: *A Penthouse Aviary* (Museum of Modern Art, New York, 1981); Rosemary Low, *Amazon Parrots* (Basilisk Press, London, 1983); Rosemary Low, *Macaws* (Rudolph d'Erlanger Publishing, London, 1987)

Louisa Chase
Bramble. 1980. Oil on canvas. 182 × 243.8 cm
Born in 1951 in Panama City, Panama
Lives in New York
Bibl: H. Fox, M. McClintic, P. Rosenzweig, *Content* (Smithsonian Institute Press, 1984)

Maria Chevska
Not Drowned. 1984. Oil on canvas. 91.5 × 76 cm
Born in 1948 in London
Lives in London
Dealer: Bernard Jacobson Gallery, London
Bibl: R. Ayers, T. Godfrey, *Landscape, Memory and Desire* (Arts Council, 1985); G. Calvert, J. Morgan, M. Katz, *Pandora's Box* (Trefoil, London, 1984)

Eileen Cooper
Safe and Sound. 1985. Charcoal on paper. 76.2 × 55.9 cm. Private Collection
Born in 1953 in Glossop, Derbyshire
Lives in London
Dealer: Benjamin Rhodes Gallery, London

Janet Fish
Hunt's Vase. 1984. Oil on canvas. 147.3 × 91.4 cm
Born in 1938 in Boston, Massachusetts
Lives in New York
Dealer: Robert Miller Gallery, New York
Bibl: C. Ratcliff, *The World of the Painting* (Robert Miller Gallery Catalogue, 1985); G. Henry, *Janet Fish* (Robert Miller, 1987)

Louise Fishman
Cinnabar and Malachite. 1986. Oil on linen. 127 × 99.1 cm
Born in 1939 in Philadelphia, Pennsylvania
Lives in New York
Dealer: Baskerville and Watson, New York

Jane Freilicher
In Broad Daylight. 1979. Oil on canvas. 70 × 80 cm. McNay Art Museum, gift of the Semmes Foundation, San Antonio, Texas
Born in 1924 in Brooklyn, New York

Lives in New York and Long Island
Dealer: Fischbach Gallery, New York
Bibl: R. Doty (ed.), *Jane Freilicher* (Taplinger Publishing Co., New York, 1986)

Jean Gibson
Breakout III. 1985. Mixed media. 45.7 × 91.4 cm. Private collection
Born in 1935 in Staffordshire
Lives in London
Bibl: M. R. Beaumont, *Jean Gibson* (Minories and Oriel Catalogue, 1985)

Nancy Graves
Cantileve. 1983. Bronze with polychrome patina. 245 × 170 × 135 cm.
© DACS 1988. Collection of the Whitney Museum of American Art.
Purchased with funds from the Printing and Sculpture Committee
Born in 1940 in Pittsfield, Massachusetts
Lives in New York
Dealer: Knoedler Gallery, New York
Bibl: L. Cathcart, *Nancy Graves: A Survey 1969–1980* (Albright-Knox Art Gallery Catalogue, 1981); E. A. Carmean et al., *The Sculpture of Nancy Graves* (Hudson Hills Press, 1987)

Maggi Hambling
The Search is Always Alone. 1981. Oil on canvas. 54.6 × 53.3 cm
Born in 1945 in Sudbury, Suffolk
Lives in London
Bibl: R. Gibson, *Max Wall, Pictures by Maggi Hambling* (National Portrait Gallery Catalogue, 1983); Tomlin, *Artist and Model* (Whitworth Art Gallery, Manchester, Catalogue, 1986)

Gwen Hardie
Cowardice. 1985. Oil on canvas. 220 × 160 cm
Born in 1962 in Newport, Fife, Scotland
Lives in West Berlin
Dealer: Graham Paton Gallery, London
Bibl: M. R. Beaumont, *The Human Touch* (Fischer Fine Art Catalogue, 1986); M. Allthorpe-Guyton, *Gwen Hardie* (Fruitmarket Gallery Catalogue, 1987)

Shirazeh Houshiary
Ki. 1984. Copper. 160 × 400 × 40 cm
Born in 1955 in Shiraz, Iran
Lives in London
Dealer: Lisson Gallery, London
Bibl: L. Cooke, *Shirazeh Houshiary* (Lisson Gallery Catalogue, 1984); L. Biggs, *Between Object and Image* (British Council, 1986)

Magdalena Jetelova
Stairs. 1982–4. Oak and iron. 425 cm × 180 cm × 270 cm
Born in 1946 in Sémily, Czechoslovakia
Lives in Düsseldorf and Munich
Dealer: Walter Storms Gallery, Munich
Bibl: M. Kalinovska *Magdalena Jetelova Sculptures* (Riverside Studios Catalogue, 1985)

Edwina Leapman
Dark Green Painting. 1986. Acrylic on linen. 168 × 183 cm
Born in 1934 in Hampshire
Lives in London
Dealer: Annely Juda, Fine Art, London
Bibl: S. Kent, *Edwina Leapman* (British Council Catalogue, 1980)

Judith Linhares
Red Sea. 1982. Oil on canvas. 121.9 × 182.9 cm. Collection Crocker Art Museum, Sacramento, California. Gift of Dr and Mrs William Vetter
Born in 1940 in Pasadena, California
Lives in New York
Dealer: Paule Anglim, San Francisco

Agnes Martin
White Flower. 1985. Acrylic and pencil on canvas. 182.8 × 182.8 cm
Born in 1912 in Saskachewan, Canada
Lives in New Mexico
Dealer: Pace Gallery, New York
Bibl: J. Drew, *Agnes Martin – Paintings and Drawings 1957–1975* (Arts Council Catalogue, 1975); L. Alloway, S. Delehanty, Wilson, *Agnes Martin* (Institute of Contemporary Art, Philadelphia); *Agnes Martin* (Waddington Galleries Catalogue)

Louisa Matthiasdottir
House and Sheep. 1982. Oil on canvas. 35.6 × 53.3 cm
Born in 1917 in Reykjavik, Iceland
Lives in New York
Dealer: Robert Schoelkopf Gallery, New York
Bibl: M. Strand (ed.), *Art of the Real* (Aurum Press, London, 1984); J. Perl, D. Rosenthal, N. Weber, *Louisa Matthiasdottir Small Paintings* (Hudson Hills Press, New York, 1986)

Melissa Miller
Owl in Sheep's Clothing. 1985. Acrylic on paper. 55.9 × 76.2 cm. Collection Mr and Mrs Sanford W. Criner, Jr.
Born in 1951 in Houston, Texas
Lives in Austin, Texas
Dealer: Texas Gallery, Houston
Bibl: L. Cathcart, S. Schultz, *Melissa Miller* (Contemporary Arts Museum, Houston, 1986); L. Cathcart et al., *Southern Fictions* (Contemporary Arts Museum, Houston, 1983)

Lisa Milroy
Shoes. 1985. Oil on canvas. 176 × 203 cm. Saatchi Collection, London
Born in 1959 in Vancouver, Canada
Lives in London
Dealer: Nicola Jacobs Gallery, London
Bibl: L. Biggs et al., *Current Affairs* (Museum of Modern Art, Oxford, 1987)

Joan Mitchell
Faded Air I. 1985. Oil on canvas. Diptych, 260 × 260 cm
Born in 1926 in Chicago, Illinois
Lives in Paris
Dealer: Bernard Lennon Inc. and Robert Miller Gallery, New York
Bibl: Y. Michaud, *Joan Mitchell* (Xavier Fourcade Catalogue, 1986)

Mali Morris
Black Diamond Encircled. 1986. Acrylic on canvas. 99.1 × 144.2 cm
Born in 1945 in North Wales
Lives in Greenwich, London

Kathy Muehlemann
Mesmerized. 1986. Oil on linen. 27.9 × 71.1 cm
Born in 1950 in Texas
Lives in New York
Dealer: Victoria Oscarsson Inc., New York

Catherine Murphy
Stairwell. 1980. Oil on canvas. 104.1 × 86.4 cm. Private Collection

Born in 1946 in Cambridge, Massachusetts
Lives in Poughkeepsie, New York
Dealer: Bernard Lennon, New York
Bibl: L. Nochlin, *Catherine Murphy* (Xavier Fourcade Catalogue, 1985);
Boothe-Meredith, Martin, L. Nochlin, Perlstein, *Real, Really Real, Superreal*
(San Antonio Museum of Art, Texas, Catalogue, 1981)

Elizabeth Murray
Deeper than D. 1983. Oil on canvas. 269 × 259.1 cm. Private Collection,
New York
Born in 1940 in Chicago, Illinois
Lives in New York
Dealer: Paula Cooper Gallery, New York
Bibl: L. R. Armstrong, *Five Painters in New York* (Whitney Museum
Catalogue, 1984); Plous, *Scapes* (University Art Museum Santa Barbara,
1985); R. Smith, Clifford S. Atley, E. Murray, *Elizabeth Murray: Paintings and
Drawings* (Abrams, Catalogue, 1987)

Christa Näher
Brücke. 1987. Oil on canvas. 90 × 50 cm
Born in 1947 in Lindau, Bodensee
Lives in Cologne
Dealer: Janine Mautsch, Cologne
Bibl: Stuart Morgan, *Christa Näher* (Frankfurt, 1987)

Alice Neel
Mother and Child (Nancy and Olivia). 1967. Oil on canvas. 99.7 × 91.4 cm
Born in 1900 in Philadelphia, Pennsylvania, died in 1984
Lived in Manhattan, New York
Dealer: Robert Miller Gallery, New York
Bibl: P. Hills, *Alice Neel* (Abrams, 1983); J. Parente, *Alice Neel Paintings and
Drawings* (Nassau County Museum of Fine Art, New York, Catalogue,
1986)

Joan Nelson
Untitled (357). 1985 Pigment and wax on wood. 46.4 × 40.6 cm. Private
collection: Penny Pilkington
Born in 1958 in Torrance, California
Lives in Brooklyn, New York
Dealer: Fairbush Gallery, New York City
Bibl: L. Dennison, *New Horizons in American Art* (1985 National Exhibition
Catalogue, Guggenheim Museum)

Thérèse Oulton
Spinner. 1986. Oil on canvas. 234 × 213.5 cm
Born in 1953 in Shrewsbury, Shropshire
Lives in London
Bibl: Gidal Lampert, *Thérèse Oulton Fools' Gold* (Gimpel Fils Catalogue,
1984); S. Morgan, *Skin Deep: Thérèse Oulton* (Galerie Thomas, Munich,
Catalogue 1986); S. Morgan, *Thérèse Oulton: Letters to Rose* (Galerie
Kritzinger, Vienna, Catalogue 1986)

Ann Page
Seal. 1982. Mixed media construction. 190.5 × 190.5 × 7.62 cm
Born in 1940 in Seattle, Washington State
Lives in Los Angeles, California
Dealer: Space Gallery, Santa Monica, California
Bibl: M. Schipper, *Ann Page* (Los Angeles Municipal Art Gallery Catalogue,
1985)

Katherine Porter
Stars Hide Your Fires. 1986. Oil on linen. 204.5 × 188 cm
Born in 1941 in Cedar Rapids, Iowa

Lives in Lincolnville, Maine
Dealer: André Emmerich Gallery, New York
Bibl: Gumpert, *The End of the World* (New Museum of Contemporary Art,
New York, Catalogue, 1983/4); *Katherine Porter at Janis* (Janis Gallery
Catalogue, 1987)

Rebecca Purdum
In Three's. 1985. Oil on canvas. 210.2 × 204.5 cm
Born in 1959 in Idaho
Lives in New York
Dealer: Jack Tilton Gallery, New York
Bibl: C. Jolles, *Rebecca Purdum: Abstract Painting* (Jack Tilton Gallery
Catalogue, 1986)

Barbara Rae
Nightfall at San Miguel. 1986. Acrylic collage on board. 75 × 100 cm
Born in 1943 in Scotland
Lives in Glasgow
Dealer: Scottish Gallery, Edinburgh
Bibl: Stevenson Taylor, *Scottish Contemporary Art in London and Washington*
(Leinster Fine Art Catalogue, 1984)

Bridget Riley
Ra. 1980. Gouache on paper mounted on linen. 253.4 × 217.8 cm
Born in 1931 in London
Lives in London, Cornwall and the Vaucluse Valley in Provence, France
Dealer: Mayor Rowan Gallery, London
Bibl: S. Churchill (Series Editor), *Great Artists Series No. 86: Bridget Riley*
(Marshall Cavendish, London, 1986); R. Cummings, B. Riley, *Working with
Colour* (Arts Council Catalogue, 1984/5); R. Kudielka, *In Conversation with
Bridget Riley: Paintings and Drawings 1961–73* (Arts Council Catalogue,
1973/4)

Dorothea Rockburne
Exstasie. 1984. Oil on canvas. 206.5 × 193 × 10 cm
Born in 1921 in Verdun, Quebec
Lives in New York
Dealer: André Emmerich Gallery, New York
Bibl: N. Spector, *Working with the Golden Section 1975–76* (John Weber
Gallery Catalogue, 1976); M. Marlais, *Drawing: Structure and Curve* (John
Weber Gallery Catalogue, 1978); *Dorothea Rockburne Painting and Drawing
1982–5* (Xavier Fourcade Gallery Catalogue, 1985); B. O'Doherty,
Dorothea Rockburne: A Personal Selection 1968–1986 (Xavier Fourcade
Gallery, 1986)

Susan Rothenberg
A Golden Moment. 1985. Oil on canvas. 137.2 × 121 cm. Collection of Eli
and Edythe Broad, Los Angeles, California
Born in 1945 in Buffalo, New York
Lives in New York
Dealer: Sperone Westwater Gallery, New York
Bibl: M. Tuchman, *Susan Rothenberg* (Tate Gallery Catalogue, 1985); E.
Rathbone, *Susan Rothenberg* (Phillips Collection Catalogue, 1985); *Susan
Rothenberg: The Horse Paintings 1974–80* (Gagosian Gallery Catalogue, 1987)

Sandra Mendelsohn Rubin
Self-portrait. 1986. Oil on canvas. 61 × 37.5 cm. Collection of Nan Tucker
McEvoy
Born in 1947 in Santa Monica, California
Lives in Santa Monica, California
Dealer: Claude Bernard Gallery, New York
Bibl: A. Martin, *American Realism* (Abrams, New York, 1986); *Sandra
Mendelsohn Rubin* (Claude Bernard Gallery Catalogue, 1987)

Claire Seidl
The Eye of the Realist is Inflatable. 1986. Oil on canvas. 129.5 × 213.4 cm
Born in 1952 in Greenwich, Connecticut
Lives in New York
Dealer: Stephan Rosenberg Gallery, New York

Cindy Sherman
Untitled #122. 1983. Photograph.
Born in 1954 in Glen Ridge, New Jersey
Lives in New York
Dealer: Metro Pictures, New York
Bibl: P. Schjeldahl, *Cindy Sherman* (Pantheon Books, 1984); *Art of our Times: Saatchi Collection Volume 4* (Rizzoli, New York, 1984)

Linda Sokolowski
Binghamton Beyond Jefferson. 1985. Mixed media and collage.
116.6 × 111.8 cm
Born in 1943 in Utica, New York
Lives in Binghamton, New York
Dealer: Kraushaar Galleries, New York

Nancy Spero
The Re-birth of Venus (detail). 1984. Handprinting on paper.
50.8 cm × 1920 cm
Born in 1926 in Cleveland, Ohio
Lives in New York
Dealer: Josh Baer Gallery, New York
Bibl: J. Bird, L. Tickner, *Nancy Spero* (ICA Catalogue, London, 1987)

Pat Steir
Chrysanthemum. 1981. Oil on canvas. 1.52 × 4.56 m. Collection Gloria and Leonard Luria, Miami, Florida
Born in 1940 in Newark, New Jersey
Lives in Amsterdam, Holland and New York
Dealer: Barbara Mathes Gallery, New York
Bibl: M. Mayo, T. Castle, *Arbitrary Order: Paintings by Pat Steir* (Contemporary Arts Museum, Houston, Catalogue, 1983). C. Ratcliff, *Pat Steir Paintings* (Abrams, New York, 1986)

Pia Stern
Dream of a Departing Mentor. 1985. Oil on canvas. 167.6 × 137.2 cm.

Collection of Edward and Barbara Raymond
Born in 1953 in Berkeley, California
Lives in Berkeley, California
Dealer: Jeremy Stone Gallery, San Francisco

Michelle Stuart
Nazca Lines Star Chart. 1981–2. 300 × 420 cm. Earth from site in Nazca Plateau, Peru. Rag paper mounted on rag board. Collection Mr and Mrs Alvin Krauss, Old Westbury, New York
Born in 1940 in Los Angeles, California
Lives in New York
Dealer: Max Protech Gallery, New York
Bibl: L. Alloway, F.T. Castle, T. Sandqvist, J. Van Wagner, *Michelle Stuart: Voyages* (Hillwood Art Gallery, Long Island University, Catalogue, 1985)

Kate Whiteford
Lustra. 1984. Oil and gold pigment on canvas. 200 × 300 cm. Reproduced by kind permission of the Harris Museum and Art Gallery, Preston, Lancashire
Born in 1952 in Glasgow
Lives in London
Bibl: K. Whiteford, *Puja: Ritual Offerings to the Gods* (Riverside Studios Catalogue, 1986); M. Gooding, *British Art in Vienna* (Contemporary Arts Society Catalogue, 1986)

Alison Wilding
Nature: Blue and Gold. 1984. Brass, ash, oil, pigment. 47 × 109 × 22 cm. British Council Collection
Born in 1948 in Blackburn, Lancashire
Lives in London
Dealer: Karsten Schubert Ltd, London
Bibl: L. Cooke, *Alison Wilding* (Arts Council Catalogue, 1985); L. Biggs, *Between Object and Image* (British Council Catalogue, 1986)

Jane Wilson
Blue Carafe. 1979–81. Oil on canvas. 76.2 × 76.2 cm
Born in 1924 in Seymour, Iowa
Lives on Long Island, New York
Dealer: Fischbach Gallery, New York
Bibl: L. Cathcart, *American Still Life 1954–1983* (Contemporary Art Museum, Houston, Catalogue, 1983)

further information

Love always desires knowledge. The amateur must therefore ask, what step do I take next? This book is only the merest introduction. It should in principle (or at least in hope) lead to a sustained effort to visit whatever museums and galleries are available. More and more museums of contemporary art are being opened, and there are now few places where one cannot see something. Then, too, there are the commercial galleries, which are surprisingly tolerant of the unmoneyed viewer. Perhaps it is not so surprising: in general art dealers love art and are pleased to share it with other lovers. So, if one takes the pains, quite an amount of contemporary art is available for our pleasure. Despite this, one must be realistic. Even if one lives in New York, the recognized capital of the contemporary art world, one cannot see many of the artists in this book, not to mention the thousands more that would richly reward our viewing. There are, at the moment, 6,081 galleries in New York City, and probably a high percentage of them show work of potential interest every changing month. Who would have the time to hunt it out? Or to look closely, even when one knows what is there? Although the physical face-to-face encounter with the work of art is uncontrovertibly ideal, in actual practice we are dependent upon reproductions.

This can sound very second-rate, and I admit it is distressing to learn that Bernard Berenson did all those attributions on the strength of small black-and-white photographs. However, we are in the blessed position of having access to large and magnificent coloured reproductions, and every scholar, let alone amateur, must make devoted use of them. (I recall complaining to such a scholar about the quality of colour plates in a book on a seventeenth-century painter. The lofty answer was that one naturally only consulted the plates to recall to mind the originals. I slunk away abashed, but have since realized that the originals lie scattered all over the world – in South America, Russia, and Australia – and that the scholar in question had rarely stirred from the British Isles. To have seen with his own eyes was a fantasy. His actual knowledge had come largely from the intelligent and sensitive study of photographs.)

Moreover, as well as being accessible, reproductions have one great advantage: they can be contemplated. Conditions in a gallery are very inappropriate for seeing art in its full dimensions. There are all the distractions of a crowd and, even more, the distractions of other works on all sides. The horrors of sight-seeing, the bliss of having sight-seen, are known to us all. We can only really appreciate what we have seen at the gallery when we are in peace and can concentrate. Also, if one follows the reviews of exhibitions, one can write and obtain superb cards from most galleries, which then provide a lifetime's joy and spiritual refreshment.

Art magazines

These are the primary means of deepening our understanding of the contemporary art world. Since there can, almost by definition, be no written history of contemporary art (though I shall mention some helpful books later) our knowledge of it is largely dependent on the reviews, articles and, above all, the reproductions, in the pages of the magazines. The amount of sheer pleasure they can offer is only equalled by their wealth of instruction. Here is a list, for the English speaking, of those I have found most valuable.

britain

Every fortnight: *Arts Review* – this has a good handful of coloured illustrations, and is pleasant, intelligent and comprehensive. A good magazine for beginners.

Every month: *Art Monthly* – only black-and-white illustrations, but full of intellectual stimulus. Very good value.

Every two months: *Artscribe International* – this is the largest and most important of the British art magazines. Full of colour reproductions and with some very high-powered critical articles. It has only recently become international and has not yet fully found its distinctive voice. *Art Line International* – black-and-white illustrations and a colour supplement. This is a lively and irreverent publication that rewards serious study. It also covers the international scene and provides an excellent over-view.

Every three months: *Studio International* – some splendid illustrations and articles, but erratic in quality. *Alba* – a new Scottish black-and-white publication that is too young to be judged but is needed, considering the astonishing richness of the Scottish art-scene. *The Green Book* – a small and beautiful magazine that deals with art on a relatively simple level, and also publishes poetry. It is unique in the quality of its reproductions and in the grace of its approach.

america

There are three American art magazines, all superb productions: *Artforum*, *Art in America* and *ArtNews*. All three have a great multitude of coloured reproductions and articles of high quality. Each is quite unlike the others: *Artforum* is perhaps the most intellectual and *ArtNews* the least (though splendidly engaging and educative). *Art in America* is probably as nearly perfect as a magazine can be.

europe

Every two months: there is a German magazine with an English supplement, the *Wolzenkratzer Art Journal*, which sometimes has a good article or worthwhile colour illustrations. There is likewise an Italian magazine with an English supplement, *Tema Celeste*. This is primarily pictorial and is superb. *Malerie, Painting, Peinture* is trilingual, also a superb, but expensive, source of pictures. It appears twice a year. Best known of the European art magazines is *Flash Art*, which is always worth procuring, if only for its pictures. The emphasis is on the more raucous kinds of art, and it is more valuable for background material than for the artistic value of its contents. Very enjoyable, all the same.

Every three months: *Parkett*. This beautiful production soars above mere magazinehood. Each issue concentrates on a single and important artist, sometimes treated rather too profoundly to be immediately intelligible, but one naturally reads, and re-reads, and re-reads. Lovely pictures.

Books

The most useful books are the catalogues from group and private exhibitions. A shop that specializes in these is Nigel Greenwood Books, in New Burlington Street, London. But there are two firms I have found both unusually pleasant and helpful to deal with and both offer the great bonus of free postage for purchases over a certain amount. The first is

the big London shop, Zwemmer (24 Litchfield Street, London WC2H 9NJ). The second is purely mail order: Artbooks (PO Box 156, Chearsley, Aylesbury, Bucks. HP18 0QD). Artbooks, like Zwemmer, sends out a very useful catalogue and can be most highly recommended.

Before listing a bibliography, some preliminary remarks. I have included individual catalogues with the list of individual artists, and any unattributed remark found in the commentaries may be considered to be a quotation from the catalogues mentioned, or else from newspaper or magazine reviews. I have included some background histories of modern art in the bibliography, since the more one has studied the history of art, the more perceptive will be one's understanding of one's contemporaries. Again, before they get lost in the bibliography, I should like to single out the few books I have found fundamental. For American contemporaries, the irreplaceable book is *American Art Now*, by that consistently elegant writer, Edward Lucie-Smith. The pictures are small, but very useful. For British art there is nothing quite as good, but the best is *The British Art Show*, an Arts Council Exhibition Catalogue. Here it is the pictures that matter, whereas Lucie-Smith is worth reading for his text. A good general book, though it only deals with a few artists, is *The New Image*, large, beautifully illustrated, and sensitively written by Tony Godfrey. Finally, two textless books (and none the worse for it): the exhibition catalogue from the Museum of Modern Art in New York, *An International Survey of Recent Painting and Sculpture*, edited by Kynaston McShine (only black-and-white illustrations, and with some peculiar inclusions and omissions, but a basic document for research); and *New Art*, edited by Phyllis Freeman and others (a marvelous pictorial survey, mainly of the New York art-scene). Incidentally, *An International Survey* includes 266 artists, of which about 14 are women (i.e. just over 5 per cent); *New Art* includes 117 artists, of which about 29 are women (25 per cent). And, as an indication of the diversity of contemporary art, only about 6 women are in both selections. Also essential material, and a joy on every page, are the four volumes of the Saatchi Collection: *Art of our Time*. If one could only choose one book, this, in four volumes, would be the choice.

background reading

H. H. Arnason, *A History of Modern Art* (London, 1977)

Magdalena Dabrowski, *Contrasts of Form* (New York and London, 1985)

Werner Haftmann, *Painting in the Twentieth Century*, 2 vols. (New York, 1965)

Robert Hughes, *The Shock of the New* (London, 1980)

Sam Hunter (Introduction), *The Museum of Modern Art, New York* (London, 1984)

Edward Lucie-Smith, *Art Today* (Oxford, 1983 and 1986)

Edward Lucie-Smith, *Movements in Art Since 1945* (London, 1984)

Edward Lucie-Smith, *Lives of the Great Twentieth-Century Artists* (London, 1987)

Harold Osborne, *The Oxford Companion to Twentieth-Century Art* (Oxford, 1981)

John Russell, *The Meanings of Modern Art* (London, 1981)

Peter Selz, *Art in Our Times* (London, 1981)

exhibition catalogues

American Art of the Seventies, Albright-Knox Art Gallery, Buffalo, New York (1979)

A New Spirit in Painting, Royal Academy, London (1981)

Real, Really Real, Superreal, Museum of Art, San Antonio, Texas (1981)

The Americans, the Collage, Contemporary Art Museum, Houston, Texas (1982)

Figures, Forms and Expressions, Albright-Knox Art Gallery, Buffalo, New York (1982)

Zeitgeist, West Berlin (1982)

American Still Life, Contemporary Art Museum, Houston, Texas (1983)

John Moore's Liverpool Exhibition, Walker Art Gallery, Liverpool (1983, 1985, 1987)

New Art at the Tate, Tate Gallery, London (1983)

The British Art Show, Arts Council, London (1984/5)

Content: A Contemporary Focus, Hirshhorn Museum, Washington (1984)

La Grande Parade, Stedelijk Museum, Amsterdam (1984)

The Hard-Won Image, Tate Gallery, London (1984)

International Survey of Recent Painting and Sculpture, Museum of Modern Art, New York (1984)

Carnegie International, Museum of Art, Carnegie Institute, Pittsburgh (1985)

New Image Glasgow, Third Eye, Glasgow (1985/6)

The Proper Study, Lalit Kali Akademi, Delhi (1985)

Representation Abroad, Hirshhorn Museum, Washington (1985)

Scapes, University Art Museum, Santa Barbara, California (1985)

The British Show, Art Gallery of New South Wales, Australia (1985)

An American Renaissance: Painting and Sculpture since 1940, Museum of Art, Fort Lauderdale, Florida (1986)

Artist and Model, Whitworth Art Gallery, Manchester (1986)

Between Object and Image, British Council, London (1986)

British Art in Vienna, Künstlerhaus, Vienna (1986)

Falls the Shadow, Hayward Gallery, London (1986)

The Mirror and the Lamp, Fruitmarket Gallery, Edinburgh (1986)

Transformations in Sculpture, Guggenheim Museum, New York (1986)

surveys of contemporary art

Thomas Albright, *Art in the San Francisco Bay Area* (Berkeley, 1985)

Art of Our Time: The Saatchi Collection (London, 1984)

Phyllis Freeman (ed.), *New Art* (New York, 1984)

Tony Godfrey, *The New Image* (Oxford, 1986)

Lucy Lippard, *Overlay: Contemporary Art and the Art of Prehistory* (New York, 1983)

Edward Lucie-Smith, *Art in the Seventies* (Oxford, 1980)

Edward Lucie-Smith, *American Art Now* (Oxford, 1983)

Alvin Martin, *American Realism* (New York, 1986)

Achille Bonito Oliva, *Trans Avant Garde International* (Milan, 1982)

Jean-Louis Pradel (ed.), *World Art Trends 1982* (New York, 1983)

Jean-Louis Pradel (ed.), *World Art Trends 1983–4* (New York, 1984)

Michael Strand, *Art of the Real* (London, 1984)

contemporary art criticism

Gregory Battock (ed.), *Minimal Art* (New York, 1968)

Francis Frascina (ed.), *Pollock and After* (New York, 1985)

Francis Frascina and Charles Harrison (eds.), *Modern Art and Modernism* (New York, 1982)

Peter Fuller, *Images of God* (London, 1985)

Suzi Gablik, *Has Modernism Failed?* (London, 1984)

Charles Harrison and Fred Orton, *Modernism Criticism Realism* (New York, 1984)

Hilton Kramer, *The Revenge of the Philistines* (London, 1986)

Rosalind Krauss, *The Originality of the Avant-Garde and other Modernist Myths* (Cambridge, Mass., 1985)

Harold Rosenberg, *The Anxious Object* (Chicago, 1964 and 1968)

Harold Rosenberg, *Artworks and Packages* (Chicago, 1969 and 1982)

Harold Rosenberg, *The De-definition of Art* (Chicago, 1972 and 1983)

Harold Rosenberg, *Art on the Edge* (Chicago, 1973)

Amy Baker Sandback (ed.), *Looking Critically: 21 Years of Artforum* (Ann Arbor, Michigan, 1984)

Brian Wallis (ed.), *Art after Modernism* (New York, 1986)

index